IMAGES
of America

LOST INWOOD

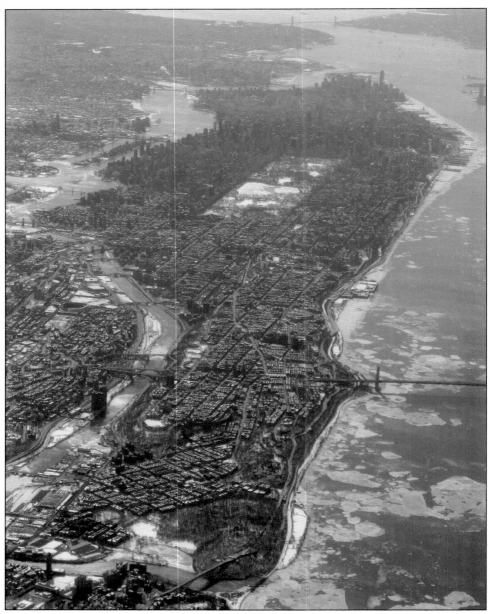

In this spectacular 2015 aerial view of Manhattan, the entire neighborhood of Inwood can be seen at the northern (lower) part of the image—where the street grid changes direction to accommodate the high ground of Fort George to the east and Fort Tryon and Inwood Hill to the west. This low-lying area is also known as the Dyckman Valley. (Photograph by Don Rice.)

ON THE COVER: The Miramar swimming pool on West 207th Street near the Harlem River provided relief from the summer heat for generations of northern Manhattan kids from the 1920s to the 1960s. The saltwater pool featured a giant slide and a sandy "beach." The domed Gould Memorial Library, designed by Stanford White, and the Hall of Fame for Great Americans colonnade are visible to the upper right. (Courtesy of Cole Thompson.)

IMAGES
of America
LOST INWOOD

Cole Thompson and Don Rice

ARCADIA
PUBLISHING

Published by Arcadia Publishing
Charleston, South Carolina

Printed in the United States of America

Library of Congress Control Number: 2018954185

For all general information, please contact Arcadia Publishing:
Telephone 843-853-2070
Fax 843-853-0044
E-mail sales@arcadiapublishing.com
For customer service and orders:
Toll-Free 1-888-313-2665

Visit us on the Internet at www.arcadiapublishing.com

This volume is dedicated to all the past, present, and future residents of Inwood.

CONTENTS

ACKNOWLEDGMENTS

In 2008, fresh off the set of the HBO series *The Sopranos*, Jason Minter opened the Indian Road Café on West 218th Street. Looking for programming to draw repeat customers, Minter enlisted authors Cole Thompson and Don Rice to present a monthly local history program: Lost Inwood. The series became a veritable *Field of Dreams*, attracting longtime residents with stories and photographs to share. When word got out that a book was in the works, the floodgates opened; neighborhood barbers, bartenders, and engineers rifled through shoeboxes looking for snapshots to contribute. Photo albums arrived in the mail. The project, rightfully, became a community endeavor.

We are indebted to the many people who contributed images, ephemera, and knowledge to this effort. Thanks to Geoff Carter, Nicole Clark, Jason Covert, Joe Dzinski, Jill Fitterling, M. Frank, Claire Anne Gray, Rich Herrera, Meredith Horsford, and Naiomy Rodriguez at the Dyckman Farmhouse Museum, the Hurst family, Lois Hughes, JoAnn Jones, Bruce Katz, Sheila Kramer, Jim Kushner, Betty Lee, Larry Lief, Alex Martinez at the Inwood Little League, Herb and Claire Maruska, Kevin "Tex" Mooney, Ray Mazzini, Jason Minter, Peter Ostrander at the Kingsbridge Historical Society, Evelyn Ruggiero, Migdalia Santos, Osaliki Sepúlveda, Donna Bazal Stone, Bob Unger, Steven Unger, and Alan Winokur. Uptown historians have been a big inspiration, so we would like to add thanks to Susan DeVries, Bob Isaac, Jim Renner, and the past titans of uptown history: Reginald Pelham Bolton, William L. Calver, and archaeologist Alanson Skinner. Thanks to Sidney Horenstein, William Parry, and Gail Addiss for their expertise, and Rob Kleinbardt, whose New Heights Realty office was a frequent site of photograph exchanges.

Special thanks to our patient spouses, Marcela Rotela and Melissa Rice, and our families for time spent in absentia. Thanks to Angel Hisnanick, our expert Arcadia editor, and of course, to the New York City museums, libraries, and historical organizations whose assistance proved invaluable.

Uncredited images are from the authors' private collections. Many of these old works have no clear origin. For the sake of brevity, images from the Dyckman Farmhouse Museum will be captioned "DFM," and New York Public Library images will be marked "NYPL."

Finally, we thank you, the reader. Enjoy *Lost Inwood*.

INTRODUCTION

Shortly after the turn of the 20th century, Rev. George Shipman Payson delivered a final sermon inside a wood-frame country chapel in northern Manhattan. It was the end of his four-decade-long ministry, one that the retiring preacher ruefully regarded as "forty years in the wilderness."

The congregation of the Mount Washington Presbyterian Church resided on Manhattan's northern tip in a neighborhood called Inwood, an area north of Washington Heights that roughly spans the Dyckman Valley floor near West 192nd Street north to the Spuyten Duyvil.

"We lived ten miles from a beefsteak," Payson recalled. "Table supplies had to be ordered the day before they were needed. The nearest livery stable was three miles away, and there were no telephones . . . if poorer roads existed on the continent, they were not within the limits of Manhattan Island."

Payson's grim recollections came at a critical moment in the region's development, just as Inwood was making the transition from farm to city. And while a modern reading of Payson's timeworn memories certainly conjures up a *Lost Inwood*, the neighborhood's early history stretches back much further, to a distant, prehistoric time when mastodons roamed a primeval uptown.

About 17,000 years ago, northern Manhattan and much of New York City was encased in glacial ice. Evidence of the ice sheet's retreat is today visible in Inwood Hill Park, where smooth, bowl-shaped glacial potholes, eroded by swirling meltwater, can be explored trailside. As forests returned, giant mammals, including mastodons, foraged amid lush vegetation, leaving behind teeth and tusks. Humans arrived as well, depositing clues about their lives in the form of fire pits, arrowheads, pottery, oyster shells, and occasionally, their buried dead.

Explorer Hendrick Hudson sailed into New York Harbor in 1609 and journeyed up the North River, possibly encountering the Lenape who lived near Spuyten Duyvil. Before long, the Dutch West India Company established a trading post at the foot of New Amsterdam, and Dutch immigrants began to arrive, eventually displacing the Lenape. By the 1670s, the land at the top of Manhattan had been claimed by two of these settlers. The new landowners, Jan Dyckman and Jan Nagel, then engaged a tenant farmer to improve the property—for the unusual price of one hen per year.

For much of the American Revolution, during British occupation of the region (1776–1783), the Dyckmans endured a self-imposed exile outside Inwood. Some served as guides for American marauding parties as the conflict dragged on. During these bloody years, large numbers of British soldiers and Hessian mercenaries lived in crude improvised huts throughout the region. Detritus from their entrenchment include musket balls, uniform buttons, broken bottles, and other castoffs of daily life.

Landowners returned when the fighting ceased, and the neighborhood relaxed back into its former sleepy agrarian existence. Only occasionally, perhaps upon finding an arrowhead or musket ball in a field or garden, did the past intrude upon the present. Memories of New York's history as a slave state faded after emancipation laws brought slavery to a legal end in 1827. A former slave cemetery on Tenth Avenue was all but forgotten.

Early 19th century residents rallied to create an educational system in a region where none existed. In 1818, Elizabeth Hamilton and Jacobus Dyckman founded the one-room Hamilton Free School near today's intersection of Broadway and West 189th Street. The school provided free education to its young charges. Public School 52 later opened on Academy Street in 1858. The community also established a lending library decades before comparable city services arrived.

In the 1840s, a train depot opened at Tubby Hook on the Hudson River, and the neighborhood's first "commuter," architect Samuel Thomson, arrived. Thomson built an airy mansion atop Inwood Hill, as well as Reverend Payson's church near Dyckman Street and Broadway. Practically overnight, a town sprang up. For several decades, Inwood became a fashionable destination where the downtown merchant class built lavish weekend retreats. Soon, Brooks Brother Elisha Brooks, retail titan Joseph McCreery, *Puck* magazine publisher Joseph Keppler, and Isidor Straus of Macy's all had places atop the hill. When the railroad inexplicably changed the name of the Tubby Hook station to Inwood in 1864, the name stuck.

In 1871, the good times came to a full stop when train service was sharply reduced. The already remote region became nearly inaccessible when trains were rerouted to the Bronx side of the Harlem River. Without the railroad, Inwood was once again an isolated backwater. The merchant class abandoned their properties. The Dyckman family moved out of their farmhouse. Dickensian institutions began to populate Inwood Hill—a tuberculosis sanitarium, a home for unwed mothers, and a House of Mercy for women whose behavior deviated from Victorian norms. Inwood Hill became a dumping ground for society's outcasts.

The sale of hundreds of acres of Dyckman land in four auctions beginning in 1868 spurred real estate speculation. By the 1890s, streetcars arrived atop Fort George, and road improvements were gathering momentum. Ideas for development came and went. A change was in the air.

During this time, an unlikely pair of self-taught archaeologists, Reginald Pelham Bolton and William Calver, engineers by day, uncovered remarkable relics related to the Native Lenape people and the American Revolution. Using simple metal rods called "sounders," the lifelong friends carefully probed loose soil disturbed by work crews. The entire neighborhood was, after all, under construction. The noisy and chaotic landscape proved a fertile hunting ground for the Victorian duo.

The pair unearthed a stunning piece of Lenape pottery on West 214th Street near Tenth Avenue in 1906, embedded in the soil of a freshly cut embankment. Arrowheads, stone blades, and even cave-like shelters in Inwood Hill rounded out the remarkable tale of Inwood's distant past. Similar digs on the Dyckman farm, the largest and oldest of the region's former Dutch *bouweries*, unearthed countless relics from the American Revolution.

Then, suddenly, the city arrived. The completion of an elevated subway line in 1906, and later, the A train in the 1920s precipitated a residential building boom. Parks arrived with the dedication of Isham Park in 1912 and Inwood Hill Park in 1926. The first neighborhood apartment buildings were erected near the corner of Dyckman Street and Broadway around 1904. Dozens more were finished by the end of the decade. By 1940, little land remained undeveloped.

Soon the neighborhood was filled with new residents attracted by low rents and developers' promises of "clean air and country living." Many newcomers came from Germany and Ireland. New Yorkers, Swedes, Poles, and even an enclave of Japanese rounded out the mix.

By the 1960s, many within these early groups had moved to suburbia. Newcomers, particularly immigrants from the Dominican Republic, quickly filled the void. Musicians, artists, actors, and writers were also attracted by lower rents and convenient access to downtown.

Today, Inwood, the "little backwoods village" Reverend Payson once described as nestled in "a pocket between two great rivers, beyond which it could not expand," faces a new population boom as updated zoning laws take effect.

What will life be like for Inwood residents in 10, 50, or 100 years? Whatever the future brings, we hope this book will help readers remember Inwood's past—from the ice ages to the present day.

One

EARLY UPTOWNERS

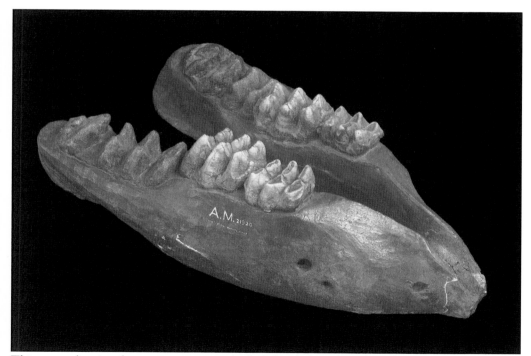

This mastodon jaw fragment was unearthed 21 feet below the sidewalk in an old peat bog by workmen digging the foundations of 2–12 Seaman Avenue and 37–49 Payson Avenue in 1925. Additional remains were discovered near today's Ring Garden in 1885. A three-foot-long partial tusk was found during the widening of the Harlem Ship Canal in 1891. (Specimen AMNH 21920, American Museum of Natural History, Paleontology, photograph by Mick Ellison.)

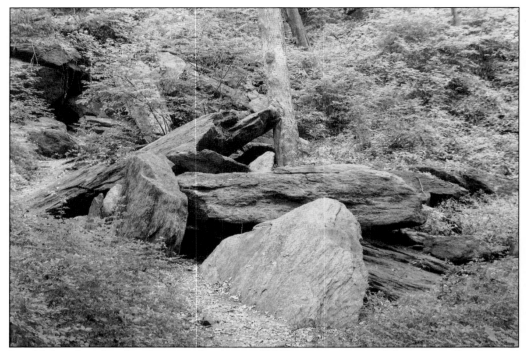

Landslides after the glacial retreat that began 17,000 years ago created these "caves" in Inwood Hill Park. The site was once a seasonal home to a group of indigenous Lenape people. Early 20th century archaeologists discovered pottery, stone tools, and other artifacts of daily life inside the small chambers formed by the fallen Manhattan schist.

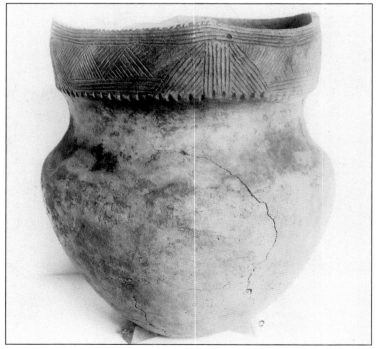

William Calver unearthed this beautifully incised Lenape vessel on West 214th Street near Tenth Avenue in 1906. The pot had been embedded in a freshly graded hill and was noticed after being exposed by rainfall. Archaeologists believe the pot had been "killed," meaning a hole had been punched near the base before the vessel was deliberately buried. The pot measured 13.5 inches in height. (Courtesy of DFM.)

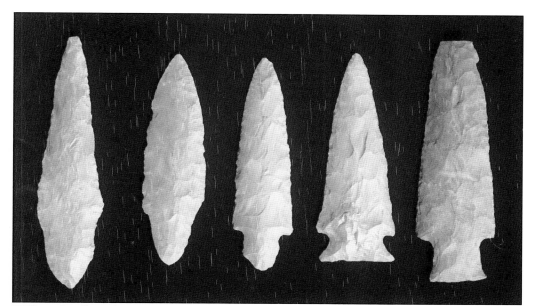

William Bradley Isham unearthed four flint blades (left) in his garden near West 215th Street. They likely date from the early to middle Woodland period about 1,500–2,500 years ago and may have been traded from the Midwest. They resemble tools made by the Adena and Hopewell "Mound Builders." The fifth point (right) was found near Academy Street and Seaman Avenue. (Courtesy of National Museum of the American Indian, Smithsonian Institution, NO5556.)

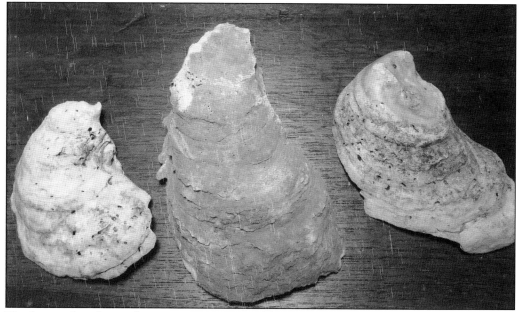

The Lenape found nourishment in oysters scooped from the once pristine waters of Spuyten Duyvil Creek. Early 20th century archaeologists discovered numerous heaps of shells, called middens, throughout the neighborhood. Some middens are clearly detritus, or trash heaps. Others protected the remains of people or dogs. The shells pictured here were found over the last several decades in Isham Park and Inwood Hill Park.

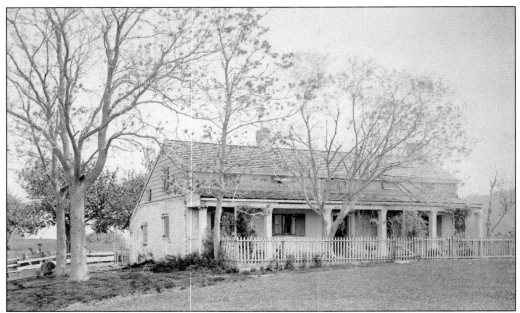

Third generation Dutch settler Jan Nagle built Inwood's Century House in 1736. The residence along the Harlem River, near today's West 213th Street, predated the Dyckman farmhouse by nearly 50 years. Three of Nagle's sons, all lifelong bachelors, occupied the dwelling during the Revolutionary War. (Courtesy of DFM.)

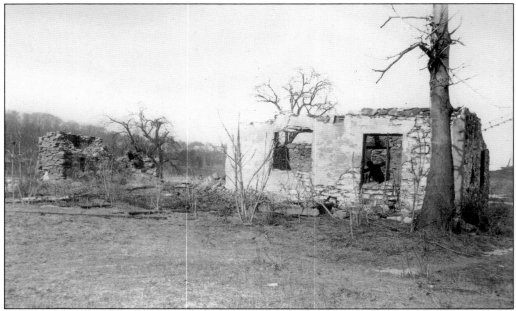

In the summer of 1900, neighborhood activists called for the preservation of the Century House. The old Nagle homestead was then thought to be one of the best-preserved examples of pre-Revolutionary architecture in the city. Sadly, the familiar landmark burned to the ground in 1903. While clearing the debris, archaeologists uncovered the foundation of an even older home on the site, possibly dating to the 1600s.

Archaeologists sifting through the charred remains of the Century House uncovered this lintel stone in 1903, which had been a part of the structure. The letters "J.N.," inscribed near the top of the stone, stand for Jan Nagle Jr., who laid the marker on May 23, 1736. The stone is now preserved in the collection of the Dyckman Farmhouse Museum.

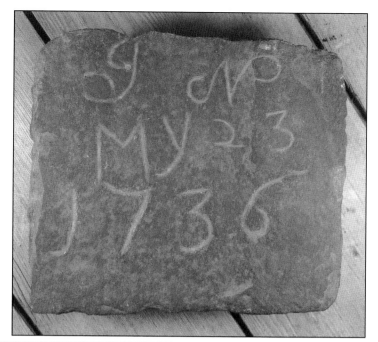

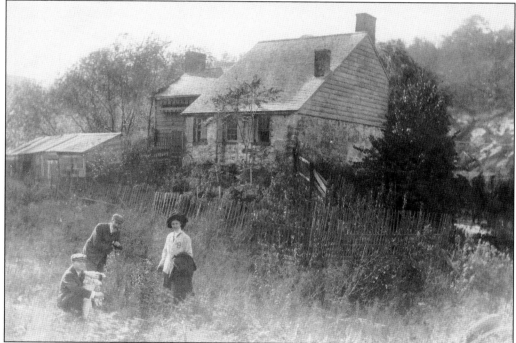

William Calver took this photograph of a cottage near Nagle Avenue and Broadway in 1911. When Calver first visited in the early 1890s, he spoke with the home's owner, John Sowerby, who shared the wood-frame structure with his 90-year-old mother, a few dogs, and some chickens. Sowerby claimed his ancestors built the humble dwelling during a yellow fever scare in 1798. (Courtesy of DFM.)

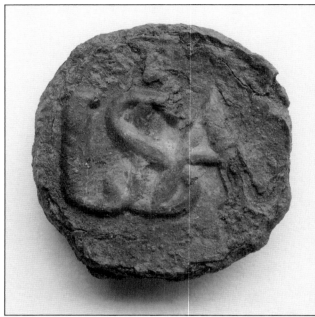

Archaeologists found this Continental army uniform button at a northern Manhattan site in the early 1900s. Similar buttons have been found at battlefields and campsites that span the duration of the Revolutionary War. William Calver reported excavating numerous examples of this intertwined USA type at Revolutionary sites throughout the Hudson Highlands. Often made of pewter, they are found in different sizes. This example is 18mm in diameter. (Courtesy of Jason Minter.)

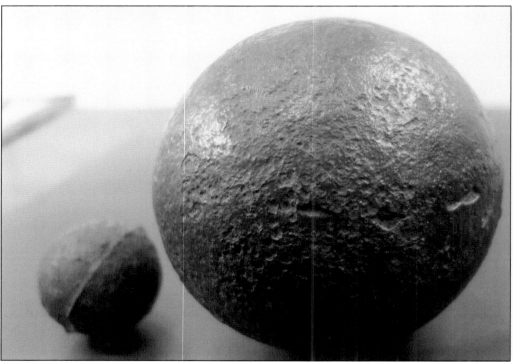

This 12-pound cannonball and smaller shot were both reportedly found on the slopes of Inwood Hill Park near Payson Avenue around 1970. Northern Manhattan was frequently used as a staging area for British troops and Hessian mercenaries after Continental forces were defeated during the battle of Fort Washington on November 16, 1776. The British occupied the area surrounding Inwood Hill until the war's end in 1783. (Courtesy of James Kushner.)

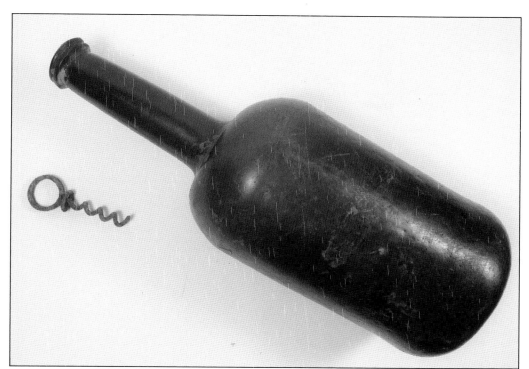

Archaeologists discovered this 18th-century green blown-glass bottle and corkscrew near the Dyckman farm. Many early American beverages were mixed with rum, often called "kill-devil," which was a lucrative byproduct of the Colonial molasses trade. Shortly after the British capture of Fort Washington, Hessian mercenaries used Hyatt's Tavern, an inn on the Spuyten Duyvil, as a guardhouse. (Courtesy of DFM.)

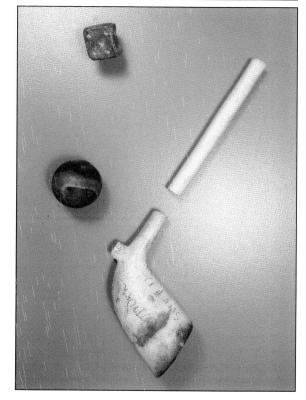

These recreational items were unearthed near the Dyckman farm by archaeologists around 1900. A soldier in the Revolutionary War likely created the lead die (top) from a musket ball during an idle moment. The green glass marble (center) may have belonged to a 19th-century child when the farmhouse was a boardinghouse. The broken clay pipe found on West 210th Street dates to the Colonial era. (Courtesy of DFM.)

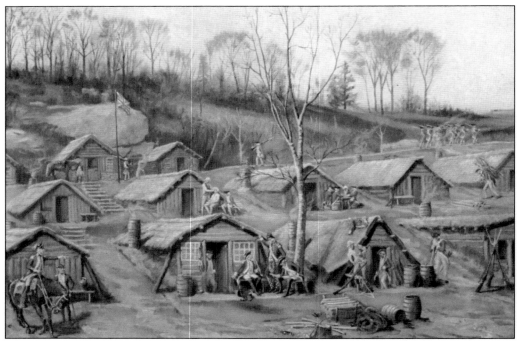

This 1915 painting by John Ward Dunsmore, entitled *Hut Camp of the 17th Regiment on Inwood Hill*, captures the daily life of British soldiers stationed in northern Manhattan during the Revolutionary War. Dunsmore accompanied a team of amateur archaeologists who uncovered more than 60 hut sites along Payson Avenue beginning in 1912. (Courtesy of DFM.)

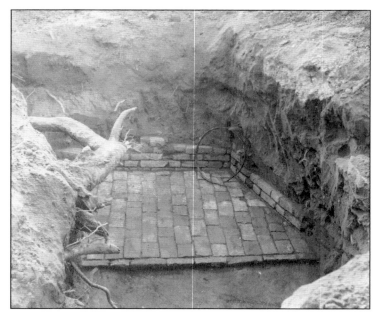

In the 1890s, William Calver discovered what appeared to be a large British hut camp along Payson Avenue. The encampment, buried beneath the remains of the old Dyckman orchard, yielded countless buttons, bullets, and bottles related to Revolutionary occupation. Seen here are the remains of a brick bake oven being excavated beneath an old tree stump. (Courtesy of DFM.)

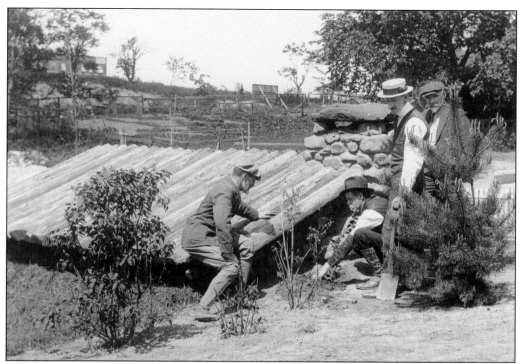

Reginald Bolton (left), John Ward Dunsmore (kneeling), and William Calver (with straw hat) reconstruct a Hessian military hut excavated near Seaman Avenue. The hut's fireplace, completely intact when discovered, was dismantled and then rebuilt stone by stone on the grounds of the Dyckman Farmhouse Museum on West 204th Street and Broadway.

The rebuilt Hessian hut looks warm and cozy on a snowy evening, but troops endured brutal winters during their years spent dug into the frozen soil of northern Manhattan. During the British occupation of the region, soldiers felled most of the trees on Inwood Hill for firewood and fortifications. The British occupied the region until Evacuation Day on November 25, 1783. (Courtesy of DFM.)

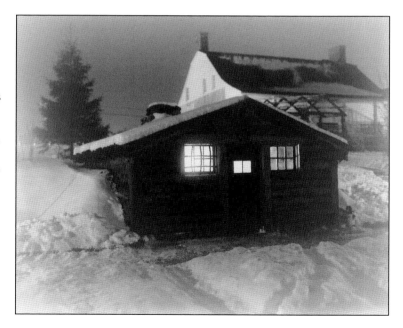

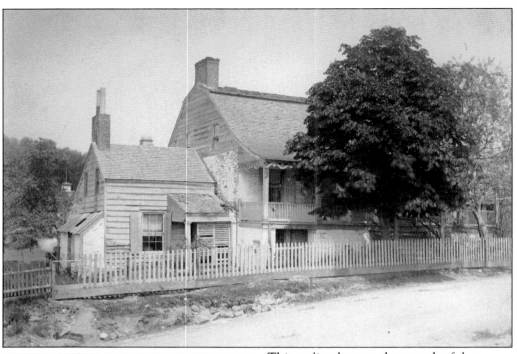

This earliest known photograph of the Dyckman farmhouse was taken around 1870. The farmhouse was one of several homes occupied by the family beginning in the 17th century and was constructed around 1784 to replace a previous home destroyed by the British during the American Revolution. Street improvements in the 1890s lowered Broadway nearly 15 feet. Broadway is seen at its original level in this image. (Courtesy of DFM.)

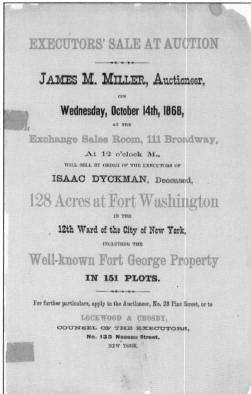

EXECUTORS' SALE AT AUCTION

JAMES M. MILLER, Auctioneer,

ON

Wednesday, October 14th, 1868,

AT THE

Exchange Sales Room, 111 Broadway,

At 12 o'clock M.,

WILL SELL BY ORDER OF THE EXECUTORS OF

ISAAC DYCKMAN, Deceased,

128 Acres at Fort Washington

IN THE

12th Ward of the City of New York,

INCLUDING THE

Well-known Fort George Property

IN 151 PLOTS.

For further particulars, apply to the Auctioneer, No. 28 Pine Street, or to

LOCKWOOD & CROSBY,

COUNSEL OF THE EXECUTORS,

No. 133 Nassau Street,

NEW YORK.

The Dyckman family began liquidating their real estate holdings in northern Manhattan beginning in 1868. A total of 360 acres were sold in a series of four auctions ending in 1871. In the final auction, the farmhouse itself was sold to Benjamin Fairchild. Over the next few decades, the farmhouse changed hands an additional 12 times. The Dyckman family reacquired it in 1915. (Courtesy of M. Frank.)

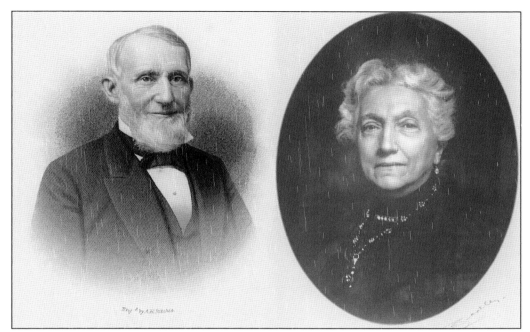

54-year-old Isaac Michael Dyckman (born James Frederick Smith) was the nephew and heir of brothers Isaac and Michael Dyckman, neither of who had children. Smith changed his name after their deaths as a condition of inheritance. He married his 35-year-old cousin, Fannie Blackwell Brown, in 1867. Their two daughters, Mary Alice and Fannie, later reacquired and restored the farmhouse before donating the home to the City of New York. (Courtesy of DFM.)

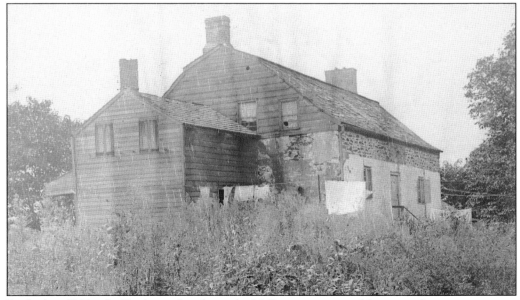

By the late 1800s, the Dyckman farmhouse had fallen into a state of disrepair; the once attractive home had become a boarding house. This late 19th century photograph captures the home's rear entrance around 1900 after the decaying back porch had been removed. The porch was rebuilt in 1915. (Photograph by C.J. Hine, courtesy of DFM.)

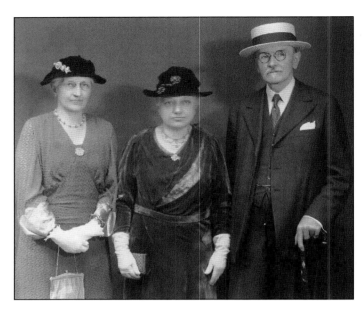

Between 1915 and 1916, Mary Alice Dyckman Dean (left), museum curator husband Bashford Dean (not pictured), Fannie Fredericka Dyckman (center), and architect husband Alexander McMillan Welch (right) undertook the painstaking renovation of the farmhouse. The Dyckman Farmhouse Museum opened to the public in 1916. As the sole surviving Dutch farmhouse in Manhattan, the site was declared both a National Historic Landmark and a New York City Landmark in 1967. (Courtesy of DFM.)

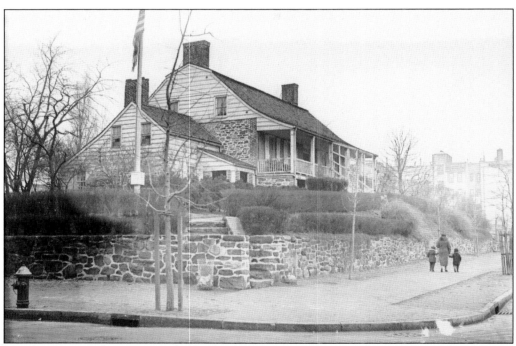

The farmhouse today is surrounded by the city where it continues to be a good neighbor, offering a diverse selection of historic, educational, and cultural programming. Dyckman family members 200 years ago were strong advocates for literacy and education. That tradition continues today with early math, reading, and science summer programs. This photograph dates from 1934. (Courtesy of DFM.)

This is the basement winter kitchen of the Dyckman Farmhouse, where many workers and family members prepared countless meals. Located on the lower level below the main living area, it would have additionally served as a source of heat for the house during the cold winter months. A separate summer kitchen is in the adjacent caretaker's cottage. (Courtesy of DFM.)

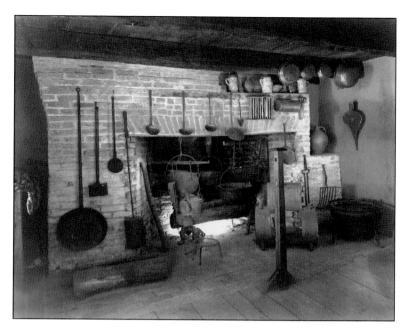

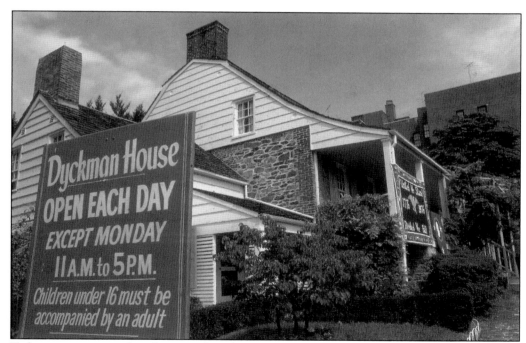

Today, visitors can explore the grounds and interior of the Dyckman Farmhouse Museum. Outside, on the half-acre of parkland surrounding the farmhouse, guests can peer inside a reconstructed military hut and reproduction smokehouse. The farmhouse interior contains period furnishings from the Dyckman collection and features a relic room where items donated by Reginald Bolton are often on display. This photograph probably dates from the 1970s. (Courtesy of DFM.)

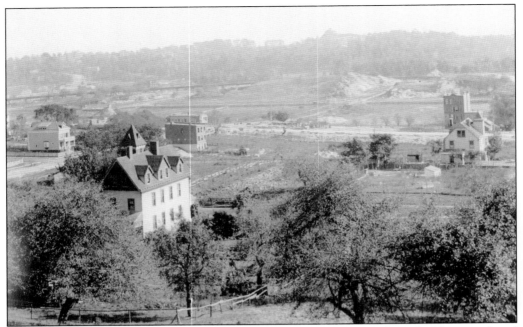

This photograph, looking east across the Inwood Valley, was taken near the end of the agricultural era in the early 1900s. Broadway, then a dirt road, slices horizontally across the center. In the foreground are the remains of the old Dyckman orchard and the McQuaid home. The Dyckman Farmhouse is barely visible near the top left. In the distance, the faint outline of the Hall of Fame for Great Americans dome makes an appearance.

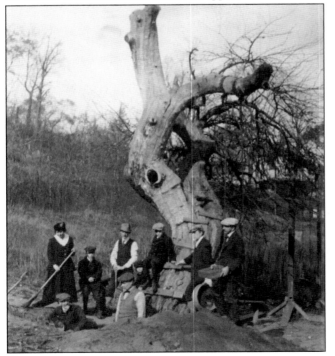

An archaeological team near Payson Avenue digs under one of the last remaining trees of the Dyckman orchard in this c. 1910 photograph. The group unearthed layers of history—arrowheads, Lenape pottery, wartime cannonballs, uniform buttons, and broken crockery—the refuse of Colonial homesteads. (Courtesy of DFM.)

William Calver digs in a field owned by William Bradley Isham along the Spuyten Duyvil Creek in this undated photograph. Isham is said to have harvested the last wheat grown on the island of Manhattan. The gentleman farmer sent part of his crop to the Chicago World's Fair in 1893. On this same grassy slope, in 1910, pioneering airman Glenn Curtiss, flying from Albany in a distance contest, landed his airplane unannounced.

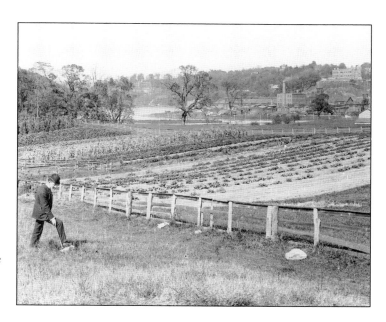

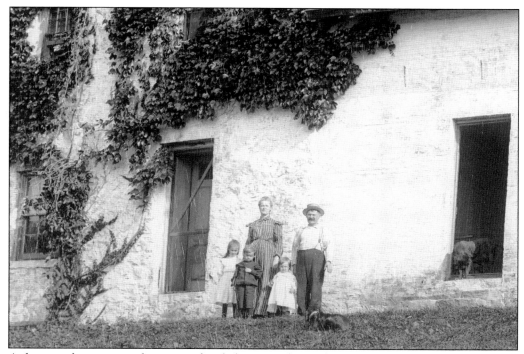

A dog in a doorway watches over a family living in the gardener's cottage of the Seaman-Drake estate in what is now the Park Terrace section of Inwood. The grounds of the estate, constructed in the 1850s, were equipped with greenhouses, freshwater wells, and a stable. This photograph is from around 1890.

Inwood still had one foot planted in its rural past when this image was captured on Dyckman Street near Payson Avenue in 1914. The juxtaposition of farms just blocks from subway stations illustrates the extreme changes happening around the neighborhood. (Courtesy of Museum of the City of New York.)

William Calver captured a final moment of Inwood's transition from farm to city in this 1911 photograph. This "very last porker reared on the whole extent of Manhattan Island," Calver recalled in his memoir, *Recollections of Northern Manhattan*, "inhabited an old fashioned sty on the site of the present day 'Baker Field,' near to Spuyten Duyvil Creek."

Two

FORGOTTEN CEMETERIES

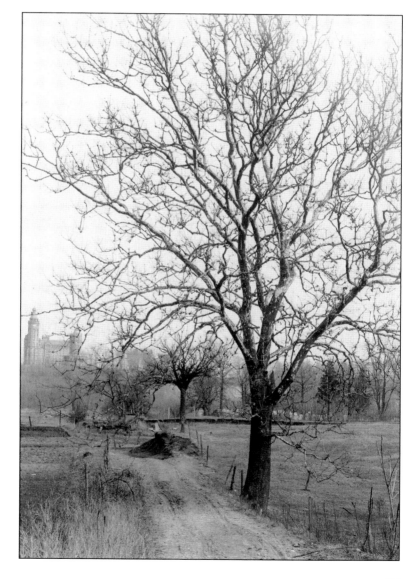

This rutted path along the line of West 213th Street east across Tenth Avenue led to a Colonial cemetery (headstones visible at center right) often referred to as the Nagle burying ground. For more than two centuries, it was the final resting place for Inwood's dead. A separate cemetery a block to the west was reserved for slaves. Slavery was abolished in New York State in 1827. This photograph is from around 1903. (Courtesy of DFM.)

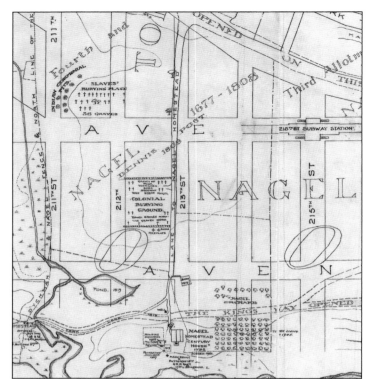

This map drafted by historian/archaeologist Reginald Pelham Bolton depicts two cemeteries a short distance from one another near the present intersection of Tenth Avenue and West 212th Street. The larger, well-marked graveyard (left center) held the dead of early European settlers; the other, an unconsecrated knoll across the roadway (upper left), served as a burial ground for enslaved humans. (Courtesy of the American Geographical Society Library, University of Wisconsin-Milwaukee Libraries.)

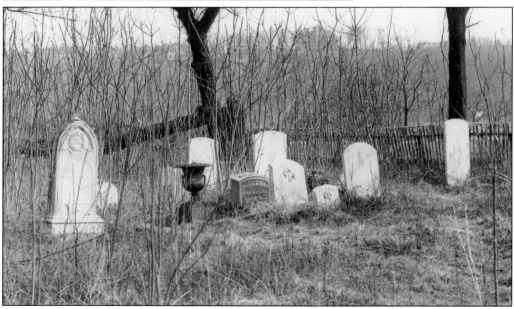

In 1926, the remains of 417 Colonial settlers buried in the Nagle Cemetery (pictured), near Tenth Avenue and 212th Street, were relocated to Woodlawn Cemetery in the Bronx. Today, the West 207th Street subway rail yard complex covers this former graveyard. Pictured is the Ryer family plot. The Dyckman family transferred their ancestral remains to Oakland Cemetery in Yonkers prior to the city's razing of the old graveyard.

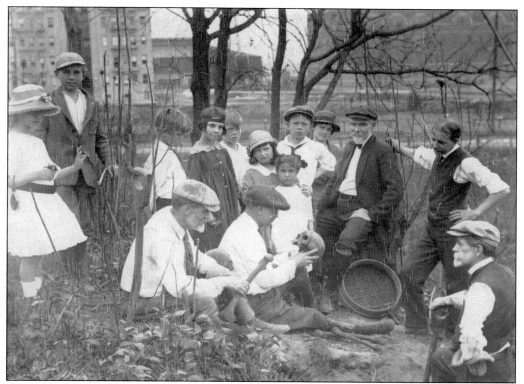

Amateur archaeologists, including members of the New-York Historical Society's Field Exploration Committee, exhume a grave in the Colonial cemetery on West 212th Street. Described in a 1922 *New York Times* article as "Emergency Historians," the six-member team was often dispatched at a moment's notice whenever anything of historical or archaeological interest was uncovered. (Courtesy of DFM.)

> RUN away on Tuefday Night laft, from Jacob Dyckman at Kingfbridge, a Negro Fellow named Will, or Wiltfhier, about 40 Years old, 5 Feet 8 Inches high, very Crooked Leggs; had on when he went away, a blue Broad Cloth Coat very fhort, Homfpun Trowfers, a Beaver Hat, half worn, with a hole through the Rim; he formerly belonged to Mr. Alfop, and likewife Mr. Keteltafs; he was feen at the Whitehall Yefterday. Whoever takes up the faid Negro, and fends him to the Work-Houfe, fhall have 3 Dollers Reward, paid by
> New-York, May 23, 1765.　　　JACOB DYCKMAN.

In this 1765 advertisement from the *New York Gazette*, Jacob Dyckman offered a $3 reward for the capture of a runaway slave. Two Dyckman slaves were counted during the 1810 census 45 years later; another 20 slaves were the property of immediate neighbors. In 1809, Jacob's nephew Jacobus Dyckman freed "a black man named Francis Cudjoe, aged about forty years." (Courtesy of NYPL, Rare Books Collection, Manuscripts & Archives Division.)

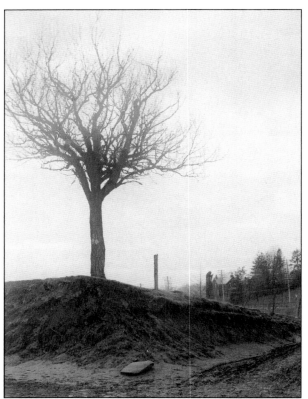

Photographer George C. Dodd captured this haunting image of a cherry tree, the lone survivor of a Colonial orchard, in 1903. In Dodd's photograph, titled "The Slave's Burying Place," a stone grave marker rests beneath a partially graded knoll near where 36 sets of human remains were unearthed. Older Native American shell pits and a dog burial were discovered adjacent to the site. (Courtesy of DFM.)

In 1903, workmen grading a hill off Tenth Avenue between West 212th and 213th Streets exposed a series of rough-hewn stones planted upright into the ground. The 36 markers were found to be gravestones, arranged in rows, as evidenced in this photograph. Archaeologists determined the site was an abandoned slave cemetery. One stone bore the inscription "March 31, 1777;" the rest were unmarked. Newspapers reported the discovery. (Courtesy of DFM.)

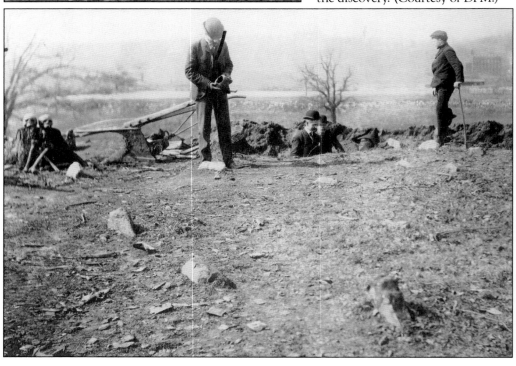

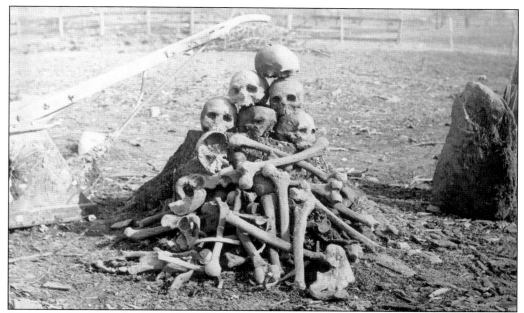

In a gruesome scene, human skulls removed from Inwood's former slave cemetery were stacked in a pyramid and photographed amid sensational newspaper coverage of the discovery. A local police captain ordered that the remains be decently reburied, but no one saw to it. Relic hunters, workers, and curious neighbors carted most of the bones away. What remained, according to news accounts, was placed in an old soapbox near the work site.

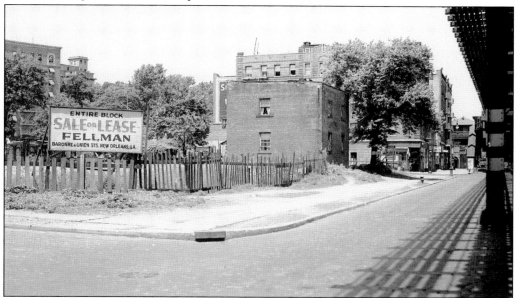

Vacant land next to a graveyard didn't discourage its development. This photograph captures a potential real estate opportunity on the corner of Tenth Avenue and West 213th Street, just across the street from the former slave cemetery, in 1933. In the early part of the 20th century, speculators bought and sold hundreds of empty lots for investment and development. New Orleans–based broker Leo Fellman handled the pictured listing.

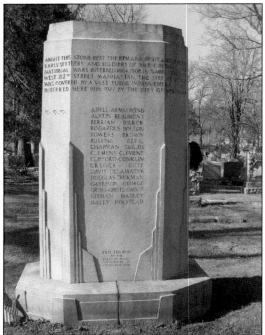

In contrast to the rough treatment given the inhabitants of the slave burial ground, Inwood's Colonial dead received the respect society normally affords the deceased. The skeletal remains of 417 individuals were relocated to lot 16150 of Woodlawn Cemetery in the Bronx in 1926. The graves sat unmarked for 10 years until 1936, when the city finally allocated funds for a monument. Today, this nine-foot-tall granite memorial marks the site.

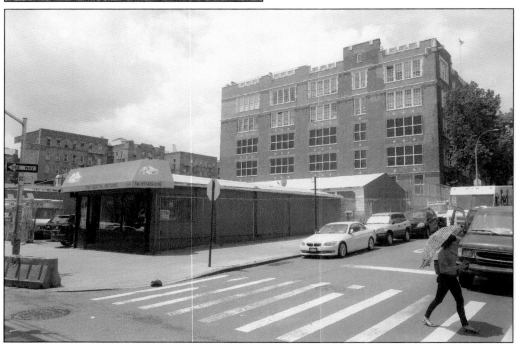

This is the site of Inwood's former slave cemetery in modern times. Ironically, the block was never fully developed. An auto-body shop and public school today cover the historic location. The former burying ground lacked a monument or signage of any sort when visited in 2018. That same year, politicians, residents, and representatives from the Dyckman Farmhouse Museum lobbied for a memorial on the former burial ground.

Three

TEN MILES FROM
A BEEFSTEAK

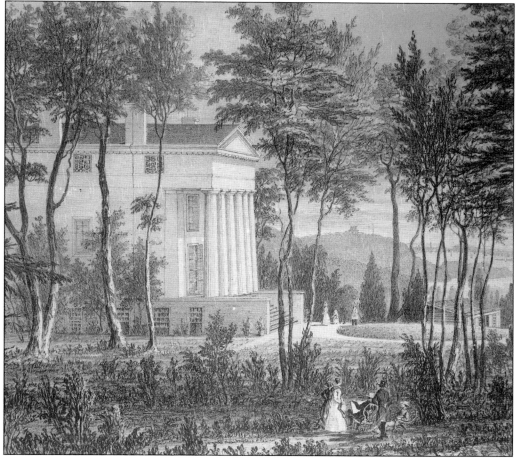

In 1840, Scotch-Irish architect Samuel Thomson bought a tract of woodland on what is today Inwood Hill. While the area was known locally as "Tubby Hook," Thomson christened his new estate "Mount Washington." Thomson later built the original Mount Washington Presbyterian Church and, likely, the wharf at Tubby Hook. This 1847 engraving is by William Jewett. (Courtesy of Geoff Carter.)

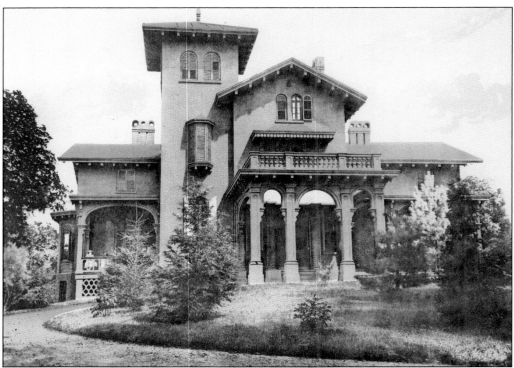

The Inwood hilltop estate of F.A. Thompson was one of many summer retreats commissioned by a wealthy merchant class in the mid- to late 19th century. Neighbors included clothier Elisha Brooks of Brooks Brothers, "Cotton King" Frederick Talcott, and *Puck* magazine publisher Joseph Keppler. Isidor and Ida Straus of Macy's eventually owned the Thompson home. They later both perished aboard the *Titanic*. This photograph is from around 1860. (Courtesy of NYPL.)

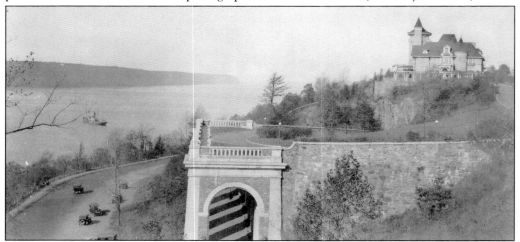

Fort Tryon Hall, the Louis XIV–inspired estate of industrialist Cornelius Kingsley Garrison Billings, dominates this early 1900s photograph. Completed in 1907, Billings lived there with his family and 23 servants for only 10 years before selling it to John D. Rockefeller in 1917. The mansion burned to the ground in 1925 and the land was later donated to the city. The arched driveway is still visible from the West Side Highway.

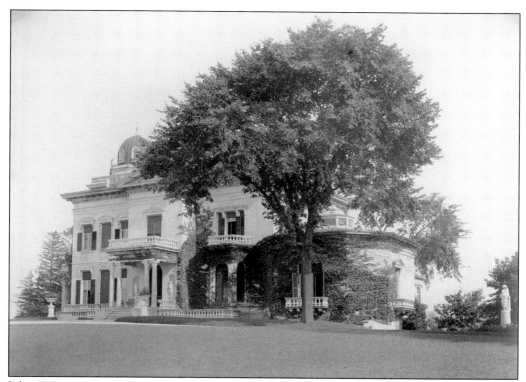

John T. Seaman and his wife, Ann, constructed the Seaman-Drake estate in 1855. The property, called "Mount Olympus" by its owners, stood on the grounds now occupied by the Park Terrace Gardens co-op. The estate featured a gleaming white-marble arch that today remains at the property's former Broadway entrance. The home was derided as "Seaman's Folly" by neighbors in the valley below—a rebuke aimed at the couple's ostentatious display of wealth.

This rare 1890 photograph provides a glimpse of the interior of the Seaman-Drake mansion. John Seaman's father, Dr. Valentine Seaman, introduced a smallpox vaccine to the United States and created the nation's first school of nursing. Ann Drake's mother was Susan Morgan, whose family launched a financial and banking dynasty. The childless couple spared no expense decorating their home.

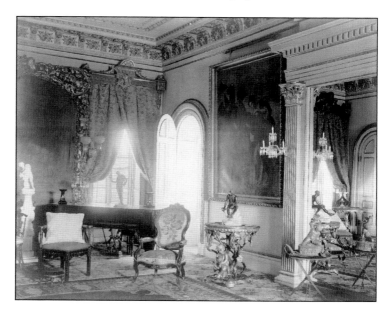

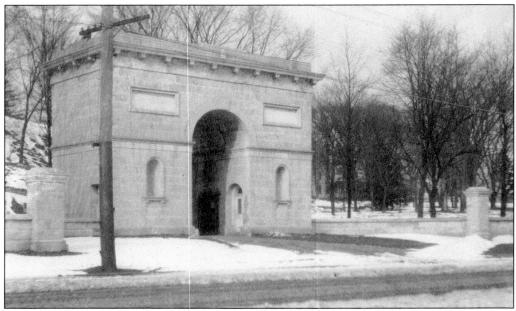

The estate's surviving arch entryway, on Broadway near West 216th Street, remains a lone witness to the incredible wealth and eccentricities of the mansion's former owners. Ann Drake-Seaman loved dogs, especially poodles. Visitors recalled gleaming tombstones and statuary, monuments to departed pets, scattered about the property. Ann, according to newspaper accounts, commissioned the arch to memorialize a fallen canine. This photograph is from around 1890. (Courtesy of DFM.)

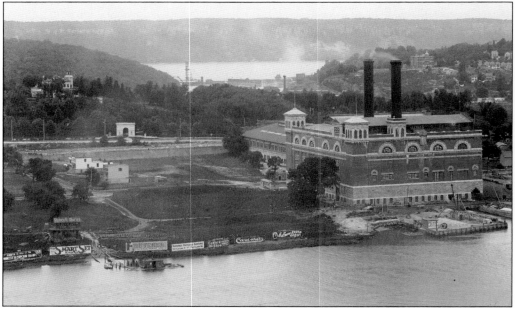

A photographer standing in the University Heights section of the Bronx captured this stunning image of upper Broadway from across the Harlem River. The Seaman-Drake arch, hewn from locally quarried Inwood marble, is visible at left center. The hulking brick coal-fired power generating station of the Third Avenue Railway System dominates the foreground in this 1903 photograph.

Architect Thomas Dwyer purchased the Seaman-Drake home in 1906. For several decades, Dwyer operated his business, the Marble Arch Corporation, out of the surviving marble arch. Beginning in the 1920s, a series of auto repair shops began to surround the structure. Dwyer later sold the property to developers who demolished the mansion. Today, the Park Terrace Gardens apartment co-op occupies the former site of Mount Olympus.

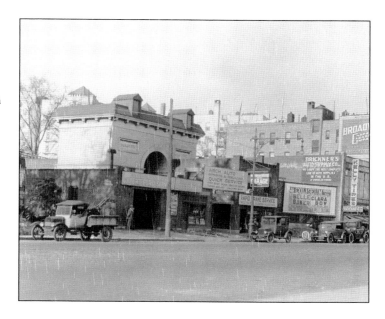

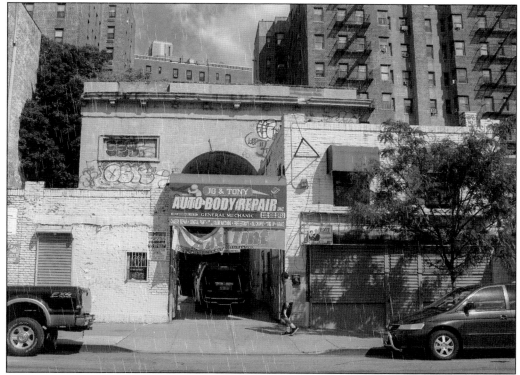

It has been said that the Seaman-Drake arch has survived more than 150 years because it never "got in the way" of development. A fire in the 1970s destroyed the interior. Today, roofless and marred by graffiti, it serves as the driveway of an auto body shop. In recent years, plans to convert the arch into a bowling alley and high-end steakhouse have fizzled. Attempts to landmark the historic structure have not been successful.

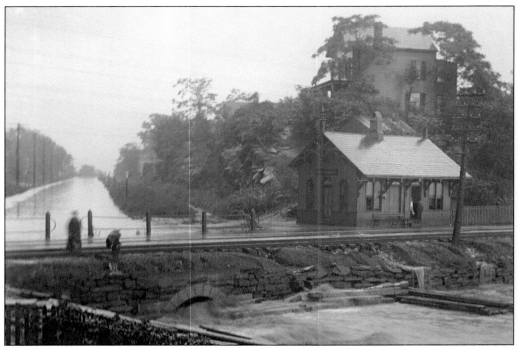

The Tubby Hook railroad station is visible to the right in this photograph from the turn of the 20th century. Photographer Robert Veitch captured this rain-soaked image near the western end of Dyckman Street at the Hudson River. Note the open storm drain at bottom left. The panorama continues on the opposite page. (Courtesy of Jason Covert.)

This image of the Mount Washington Presbyterian Church dates to around 1906. The church, seen here at the confluence of Riverside Drive, Dyckman Street, and Broadway, was demolished amid subway construction in 1929. The congregation relocated to West 204th Street and Vermilyea Avenue, where a new church was erected. (Courtesy of Jason Covert.)

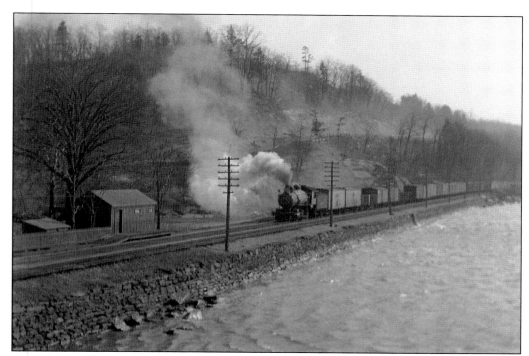

A northbound locomotive approaches the Tubby Hook depot in this early 1900s photograph by Robert Veitch. Before 1864, much of Manhattan north of Dyckman Street was called Tubby Hook. The decision to change the region's name to Inwood was likely considered as early as 1847 when the opening of the Hudson River Railroad transformed the sleepy village into a proper country town. (Courtesy of Jason Covert.)

Robert Veitch opened his general store along the Hudson River at Tubby Hook in the late 1800s. The shop became the center of commerce, news, and gossip in early Inwood. Anticipating the arrival of the subway in 1906, Veitch, using brute strength and teams of horses, literally dragged the brick structure several blocks east to be closer to Broadway and the new commercial heart of the neighborhood. (Courtesy of Jason Covert.)

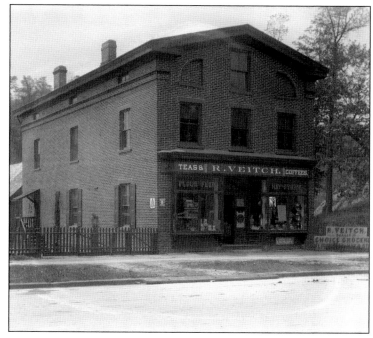

A horse-drawn carriage pauses to deliver dry goods to Robert Veitch's Dyckman Street general store around 1906. The store temporarily housed the Dyckman Library before it moved into the Flitner residence in Inwood Hill Park. Veitch's remarkable photograph collection, containing more than 100 plate-glass slides, was discovered in 2004 by his great-great-grandson Jason Covert. (Courtesy of Jason Covert.)

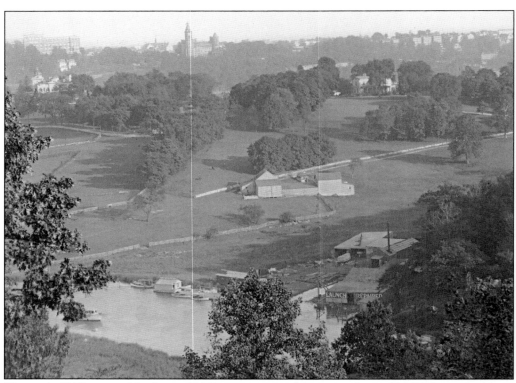

This early 1900s view of the Inwood Valley was captured from atop Inwood Hill. The outbuildings of the Isham farm are visible near the center. The Isham home is at upper right. The estate's 24 acres included greenhouses, a gardener's cottage, a cold spring, and a stable. The Webb Institute, a Bronx home and school for shipbuilders, is seen across the Harlem River to the east.

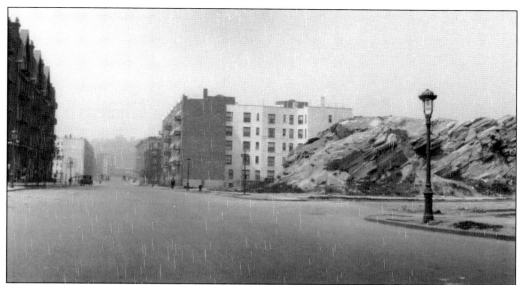

A lonely gaslight stands at the corner of Post Avenue and West 204th Street in this photograph from the 1910s. Across the street rises an enormous block of Inwood marble, a formation that underlies much of the area. Throughout the neighborhood, crews blasted away the undulating bedrock with dynamite to grade new building lots ahead of apartment construction. Old-timers say that this outcrop was still there in the 1950s.

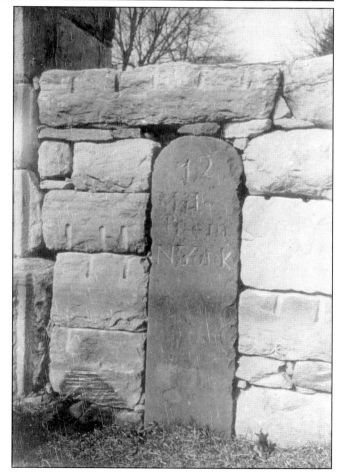

"12 Miles from N. York," reads this milestone, one of many that used to be spaced along the main roads, informing travelers of their distance from the city. William Isham recovered it near the Dyckman farmhouse, likely abandoned in a heap of debris during late 19th century road improvements. Isham embedded the brownstone marker in his property's retaining wall facing Broadway where, weatherworn, it survives today.

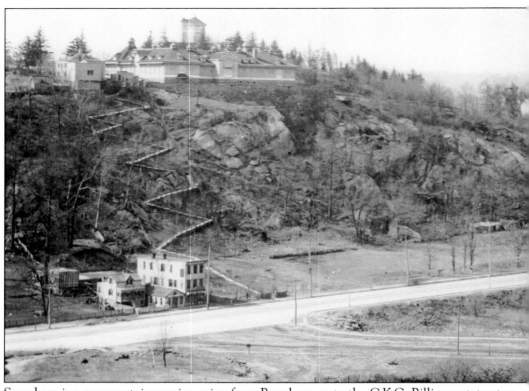

Seen here is a narrow stairway zigzagging from Broadway up to the C.K.G. Billings estate atop Fort Tryon. Getting up to the main entrance from the west side posed a similar problem. The hill was too steep to accommodate a conventional driveway. To solve it, Billings allegedly enlisted a farmer who proposed a homespun solution: "Follow a cow," he told Billings. "A cow will always

William Calver is at left in this early 1900s photograph probing the soil east of Broadway in search of historical artifacts. The gardener's cottage and ginkgo tree of the Isham estate, near the Broadway entrance of the present Isham Park, are at upper right. More than a century later, the tree still towers over the entrance to the park. (Courtesy of DFM.)

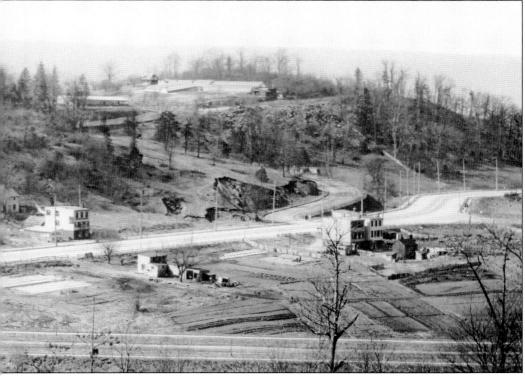

choose the easiest route." A group of large greenhouses belonging to the Billings estate is visible atop the ridge. Nagle Avenue cuts across the bottom. Between Nagle and Broadway lies the farm once maintained by Adolph Zerrenner, a veteran dispatch rider for the New York Cavalry during the Civil War. Broadway intersects with Sherman Avenue on the far right as it heads north.

A mounted policeman surveys the scene as Reginald Bolton (right) explores a shell midden near Seaman Avenue. Bolton uncovered countless artifacts related to Native American habitation as well as relics from Colonial life and the American Revolution. Over the years, the former curio-seeker became a respected historian and archaeologist. Interested children often kept Bolton company on his weekend adventures. This image was captured around 1900.

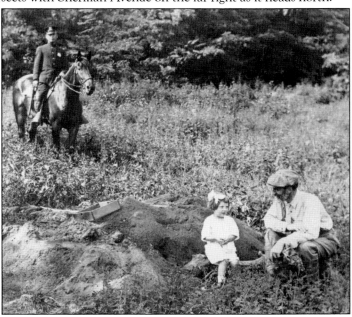

41

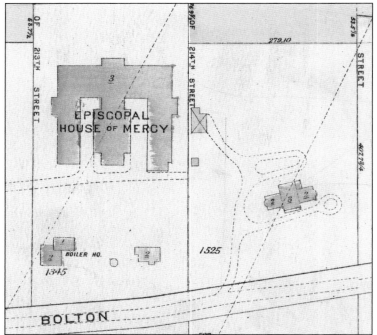

The House of Mercy was one of three institutions that lined the ridge of Inwood Hill near the turn of the 20th century. The home for "destitute and fallen women" opened in 1891. Nearby, the House of Rest cared for tuberculosis patients. Farther south, near Dyckman Street, the Magdalen Asylum kept "rescued" wayward girls and unwed mothers under lock and key. On the right is the Isidor Straus estate. This is a Bromley map, published in 1911.

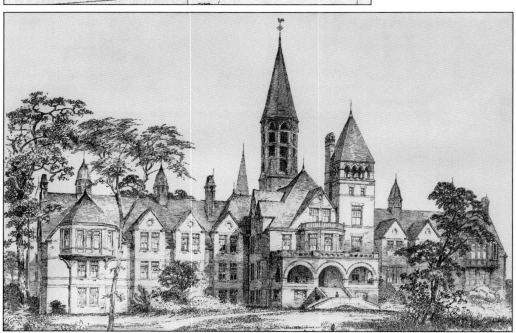

Brooklyn architect Henry Congdon designed Inwood's House of Mercy. The Sisters of Saint Mary operated the asylum under the guidance of the Protestant Episcopal Church. After a brief lease in 1921 to the New York Society for the Prevention of Cruelty to Children, the building was condemned in preparation for the 1926 opening of Inwood Hill Park. Depression-era work gangs under the direction of Robert Moses demolished the structure in the 1930s. This sketch was produced in 1890.

St. Saviour's Sanitarium was a specialized wing within the House of Mercy dedicated to the cure of substance abuse. Two-year commitments to this Dickensian rehab required the recommendation of two physicians. The St. Agnes House, in another wing, provided industrial training for homeless girls. Children as young as eight toiled in an onsite commercial laundry. (Courtesy of NYPL.)

St. Saviour's Sanitarium.

❧ Inwood-on-the-Hudson, ❧ New York City.

❖❖

A Home for the care of Women addicted to the excessive use of alcohol or drugs. ❧ ❧ ❧

❧ ❧ INCORPORATED IN 1892 ❧ ❧

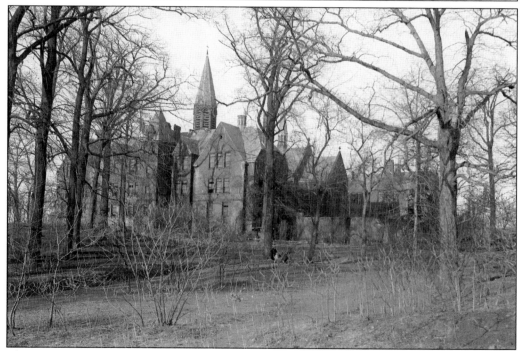

The House of Mercy closed around 1920 after sensational newspaper accounts detailed abuses that included bread and molasses diets, shaved heads, and the use of restraints. Visiting the shuttered asylum in 1933 just prior to its demolition, New Yorker writer Morris Markey described haunting graffiti including "I wish I was dead" and "God help me to get out of here," and "I was put in this House of Mercy for nothing."

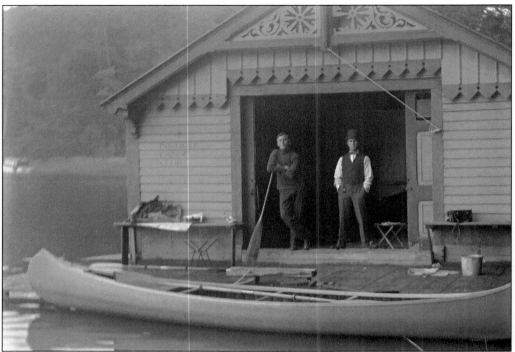

The Inwood Canoe Club is today the oldest surviving canoe club in New York City. Proud members are seen here standing in front of an early boathouse near Spuyten Duyvil Creek in a photograph taken by Robert Veitch shortly after the club's founding in 1902. Seven "Turtles," so-called after the club's mascot, have competed in various Olympic games. (Courtesy of Jason Covert.)

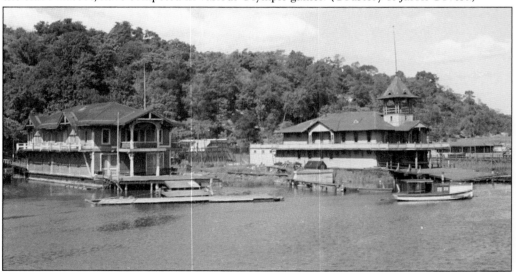

Two boathouses, the Union Boat Club (left) and the Nonpareil (right) are seen along the Harlem River near Dyckman Street in this 1935 photograph. In 1932, the Union Boat Club became one of the first clubs in the country to organize a female crew team. Other Harlem River clubs included the First Bohemian, Lone Star, Dauntless, and Wyanoke. In 1937, Robert Moses evicted nine boathouses from "Sculler's Row."

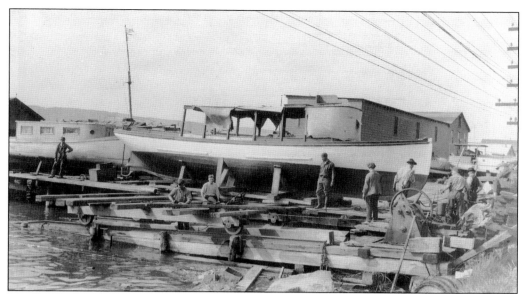

Small marine outfits along the Hudson River fared well before the launch of the Dyckman Street ferry in 1915. In the early 1900s, the region was also known for the production of watercraft. The Reliance Motor Boat Company along Spuyten Duyvil Creek produced sleek wooden speedboats. Various shipbuilders were also clustered along the eastern bank of the Harlem River in the Morris Heights section of the Bronx. This image was captured around 1910.

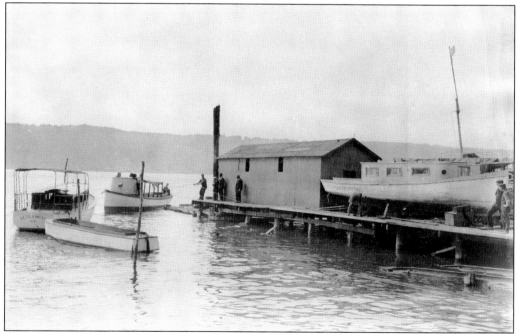

Workers repair a boat hoisted from the Hudson River in this photograph taken near Dyckman Street in the early 1900s. Not far away, along the Spuyten Duyvil Creek at West 218th Street, the Kretzer Boat Works could haul 40-footers from the water. The Ruddock Yacht Works on West 213th Street could handle 75-foot vessels.

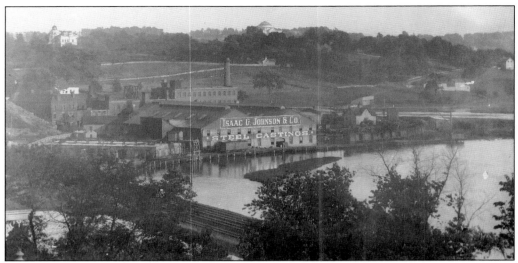

The huge block letters of the Johnson Ironworks dominate the landscape in this early image of Spuyten Duyvil Creek. The foundry manufactured cannon, shot, shell, and other implements of war beginning in 1861. In the distance, in the upper left, the Seaman-Drake Estate is visible on the hill. The dome of the Hall of Fame for Great Americans can also be seen. (Courtesy of Kingsbridge Historical Society.)

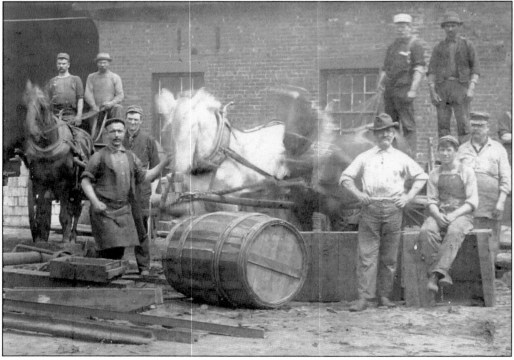

A team of horses becomes a blur of motion as foundry workers stand still for this turn-of-the-20th-century photograph. During peak production, the Johnson Ironworks employed some 1,600 workers, many of whom lived in company housing on "Puddler's Row" in the Bronx. The ironworks closed in 1923. (Courtesy of Kingsbridge Historical Society.)

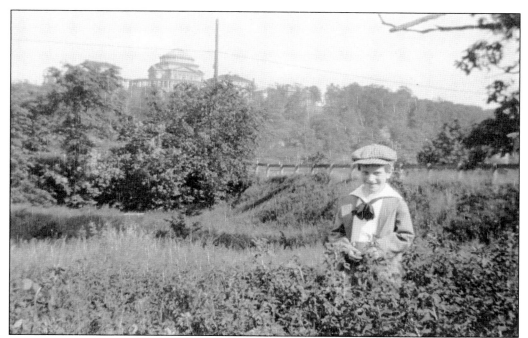

East of Broadway lies undeveloped in this tender early-20th-century photograph of young Anthony Wheeler standing in an urban meadow. Behind him, a wood-rail fence lines the country lane that would later become a heavily developed West 207th Street. In the distance, the Hall of Fame for Great Americans watches over the verdant landscape.

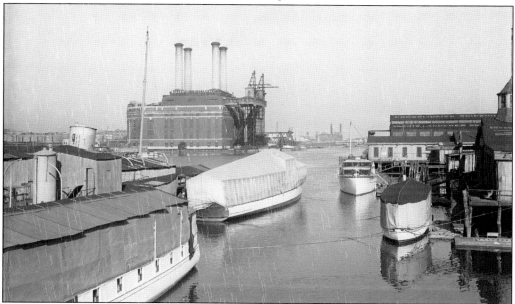

The hulking edifice of the United Electric Light & Power plant rises above Sherman Creek in this 1930s photograph. Today, Sherman Creek Park, a 15-acre oasis, breathes tranquility into this former industrial area. The park features restored wetlands, a children's garden, and the stunning Peter Jay Sharp Boathouse, which today is the only remaining boathouse along the Harlem River.

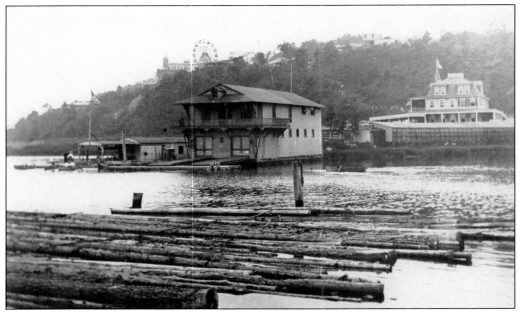

Swimmers sit on the dock of an elegant boathouse along Sherman Creek in this early 1900s photograph. To the right is Durando's Road House, a popular drinking hole known as "the Club" at the north entrance to the Harlem Speedway. A Ferris wheel rises above the Fort George Amusement Park in the distance. The entertainment center, "Manhattan's Coney Island," was located atop the north end of Fort George and today's Highbridge Park. (Courtesy of DFM.)

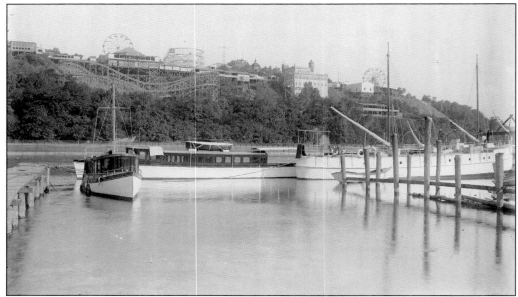

This stunning Harlem River scene was captured around 1890. In the foreground, gleaming new boats, manufactured locally, ride at anchor. The sprawling Fort George Amusement Park dominates the ridge beyond. In its heyday, silent movie star Lillian Gish hawked candy there at age 12. Hollywood titans Marcus Loew and the Schenck brothers met at the park years before founding United Artists and Metro-Goldwyn-Mayer. The pleasure ground was destroyed by fire in 1913.

Four
THE CITY ARRIVES

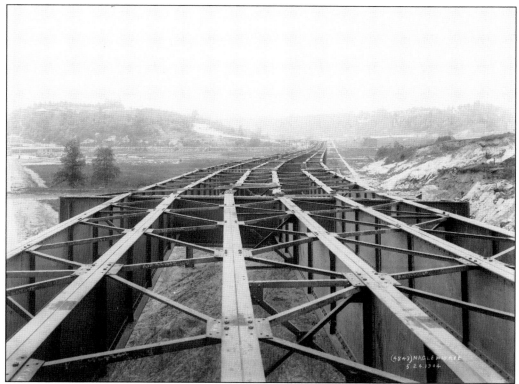

When the first subway pulled into the elevated Dyckman Street station on March 12, 1906, a once-sleepy farming community was thrust into the 20th century. Apartment houses, shops, bars, bowling alleys, and hotels were erected at a dizzying pace. This is a view south from Nagle and Tenth Avenues in 1904.

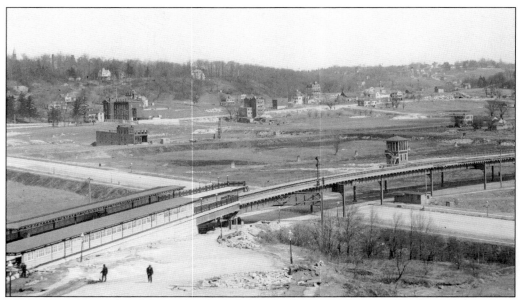

The serpentine tracks of the unfinished elevated subway wind across the floor of the empty Dyckman Valley in 1902. Inwood experienced a construction boom in the years that followed. The transformation from farm to city occurred with astonishing speed. Within 30 years, the neighborhood would be filled with apartment buildings.

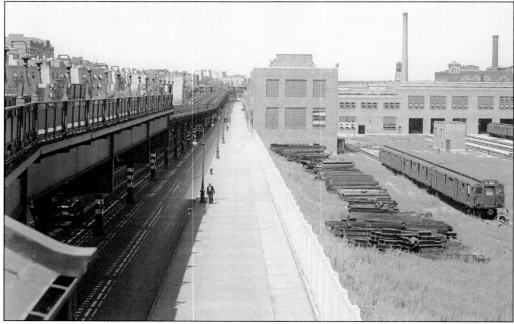

The 207th Street rail yard of the Metropolitan Transportation Authority partly covers the site of Inwood's old colonial cemetery. In the 1920s, a total of 417 sets of human remains were disinterred and relocated to Woodlawn Cemetery in the Bronx before work on the public improvement project began. The approximately 45-acre subway maintenance site suffered severe flood damage during Hurricane Sandy in 2012.

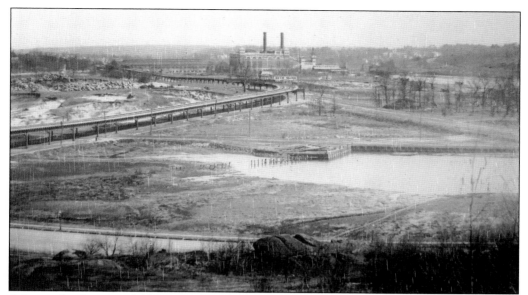

A barren landscape unfolds north of Dyckman Street in this otherworldly photograph from the early 1900s. In the distance, two smokestacks of the Kingsbridge powerhouse at West 216th Street and Ninth Avenue are visible. The plant was the largest coal-fired generating station in the world at the turn of the 20th century. This plant powered a massive grid of trolley lines in an age still dominated by horse and buggies.

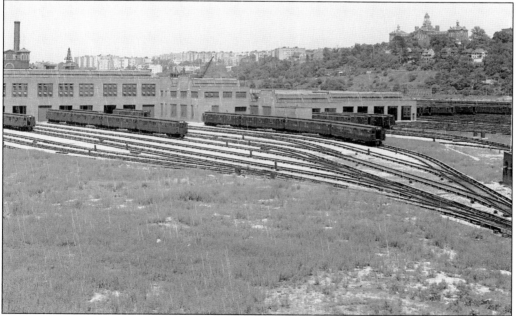

Photographer Percy Loomis Sperr captured this image of the West 207th Street rail yard in 1933 shortly after the facility was completed. Between the 1920s and 1940s, Sperr documented an often-ordinary but ever-changing metropolis. His body of work was massive; of the 54,000 old New York City photographs maintained by the New York Public Library, some 30,000 are credited to Sperr.

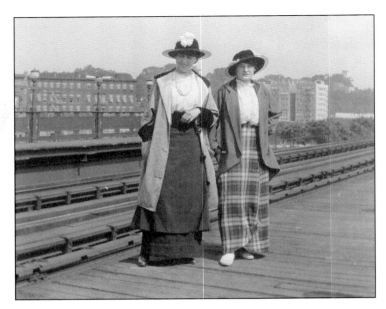

Two stylish ladies strike a pose on the northbound platform of the West 207th Street subway station in this 1919 photograph. Behind them and to the left are newly erected apartment buildings along Post Avenue. In the upper right, barely visible, the Seaman-Drake mansion overlooks the sea of new construction. It would survive until the end of 1938, when it too succumbed to the wrecking ball.

This photograph of Isham Street, between Cooper Street and Seaman Avenue, would be hard to place if not for the apartment building in the background. The apartment house, 666 West 207th Street, today overlooks the Emerson Playground in Inwood Hill Park. Isham Street, the dusty path at the bottom of the photograph, today hosts a weekly farmer's market. This photograph is from around 1917.

This Isham Park commemorative button was one of many given away when the green space opened in 1912. The image depicts the Broadway entrance to the park. A row of elm trees planted by William Isham in the 1800s along an old carriage path greeted visitors to the new uptown oasis. Isham family descendants gathered in Inwood a century later to celebrate the park's centennial in 2012.

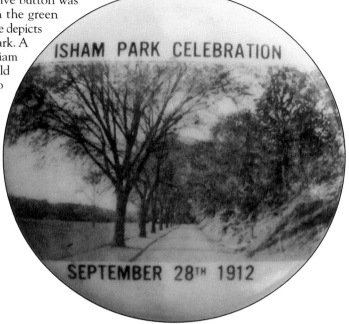

ISHAM PARK CELEBRATION

SEPTEMBER 28TH 1912

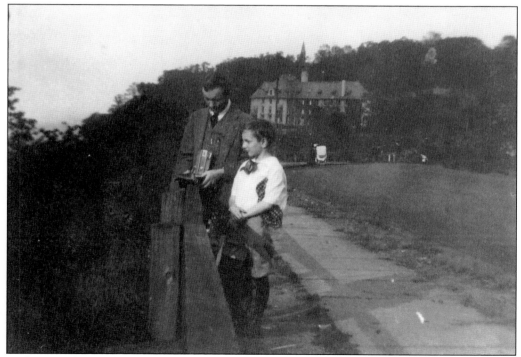

A photographer explains his craft to a curious young lad in this image captured on the Boulevard Lafayette, now Riverside Drive, around 1915. In the background, near center, the imposing edifice of the Jewish Memorial Hospital rises above Dyckman Street. The tiny spike just above the hospital is the spire of the House of Mercy on Inwood Hill.

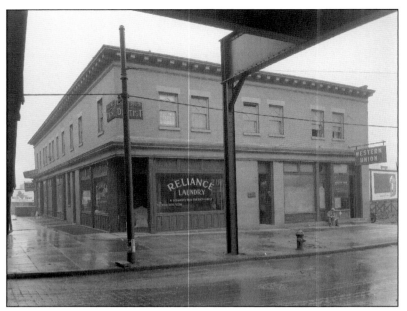

"A separate tub for each family," declares the signage of Reliance Laundry in this 1926 photograph. The attractive brick building, once located on the northeast corner of West 207th Street and Tenth Avenue, was demolished during the construction of the West 207th Street subway rail yards sometime before 1932.

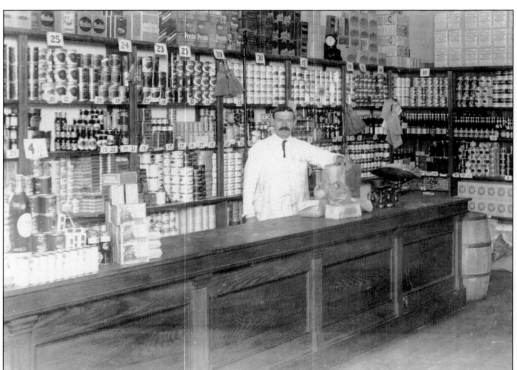

As new apartment buildings filled Inwood's empty lots, stores opened to fill the growing needs of the population. Here, John Henry Landsberg stands behind the counter of his dry goods shop at 201 Dyckman Street around 1920. Items on the shelves include Kellogg's Toasted Corn Flakes, Presto Self Rising Flour, Aunt Jemima Pancake Mix, and a variety of goods from the National Biscuit Company. (Courtesy of M. Frank.)

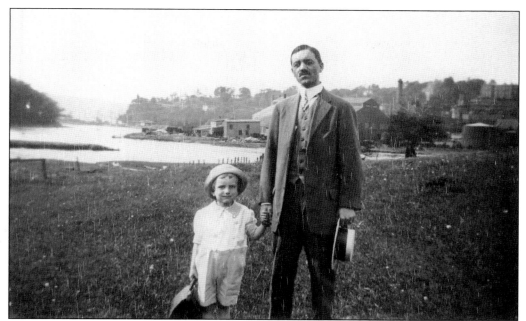

A young Anthony Wheeler and his father, Ezra, stand in a field of wildflowers in what is today Inwood Hill Park. Directly behind them, Spuyten Duyvil Creek curves around the hulking infrastructure of the Johnson Ironworks. The Wheeler family lived on West 204th Street through the early 1920s. They were avid photographers. Many of the locations in the Wheelers' unique photograph collection are recognizable today.

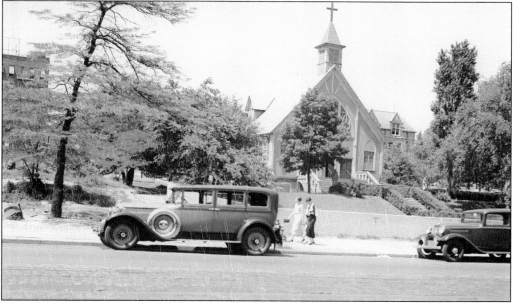

This elegant wood-framed chapel built around 1912 housed the original congregation of the Church of the Good Shepherd. The structure was moved one block west to Cooper Street in the 1930s to make room for the large Romanesque church that today guards the corner of Isham Street and Broadway.

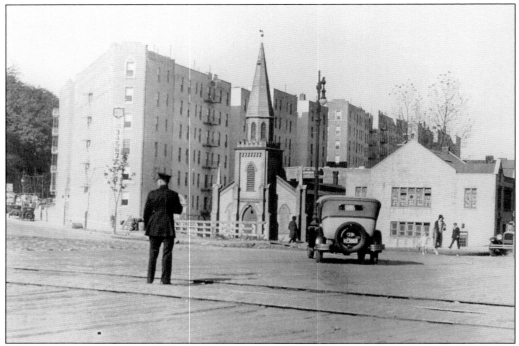

Inwood was considered a rural outpost in 1844 when Samuel Thomson constructed the Mount Washington Presbyterian Church, pictured here. By the 1920s, the city had nearly swallowed the simple wood-framed house of prayer. Behind the church is the newly completed apartment building at 1825 Riverside Drive. Thomson's little country church was condemned by the city to make way for subway construction in 1927. A new church was erected nearby on Vermilyea Avenue.

Private homes line Dyckman Street from Broadway to Tubby Hook in this frenzied 1920s image captured near Payson Avenue. Residents along this Dyckman strip, now parkland, included Jesse Root Grant, the son of Pres. Ulysses S. Grant, and retired slave ship captain William Ladd Flitner.

Charles Veitch, the son of Inwood grocer Robert Veitch, owned this garage and service station on Dyckman Street and Seaman Avenue. The younger Veitch shared his father's passion for photography. Their combined photographic record of the neighborhood spans the early 1890s through the 1930s. (Courtesy of Jason Covert.)

Numerous auto repair shops, car dealerships, and garages operated in the neighborhood in the 1920s. Some catered to competitors in the annual Fort George Hill Climb; a proving ground for early motorcars. Automobile excursionists also needed to gas up before exploring the parks and scenic byways of the New Jersey Palisades, which were accessible via the Dyckman Street Ferry.

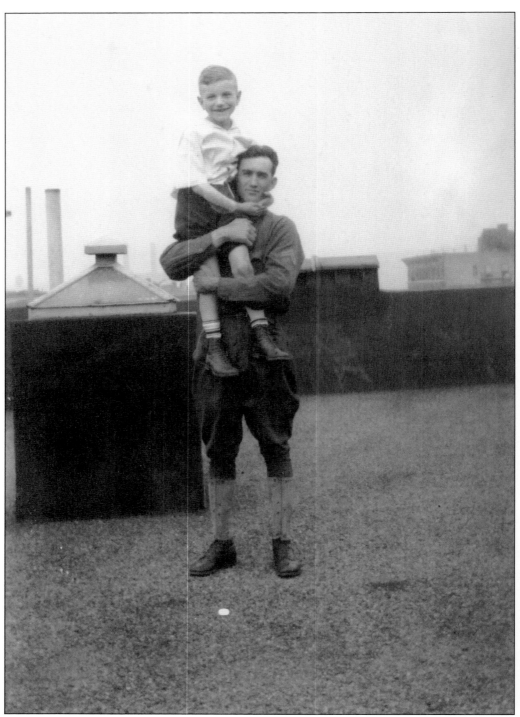

In this World War I–era rooftop photograph, likely captured atop 600 West 204th Street, a soldier lifts Anthony Wheeler high above his head. Displays of patriotism, including War Gardens planted by Japanese immigrants barred from military service, were seen throughout the neighborhood.

In an age before air conditioning became commonplace, many New Yorkers took to their rooftops to escape the summer heat. This particular "tar beach" was atop 600 West 204th Street, a building on the corner of Sherman Avenue called the Lynden.

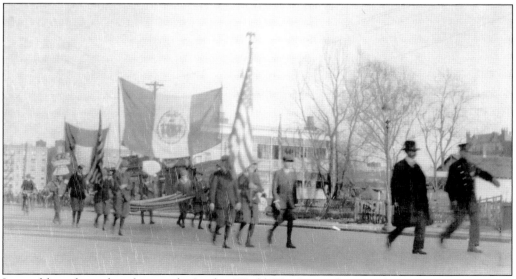

Inwood has always loved a parade. In this World War I–era photograph, participants carrying American and New York City flags march past a wood-frame building and empty lot on Sherman Avenue near Academy Street. The structure, known to later generations as the Pig 'n' Whistle pub, was still standing in 2018 at 161 Sherman Avenue.

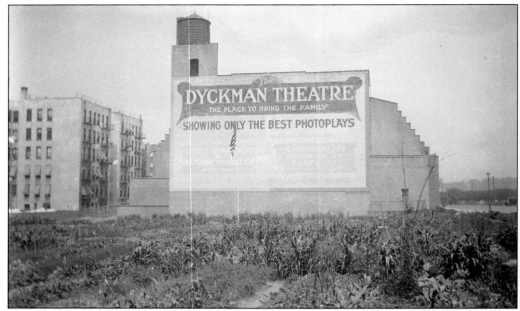

Inwood's connection to film is nearly as old as the craft itself. Early film scouts regarded the area as a prime location for cowboy films. Inwood Hill, it was said, easily passed for the American West. The Dyckman Theatre, as if in a nod to Inwood's once-bucolic simplicity, overlooks a cornfield in this photograph from the 1910s. Students studying agriculture at Public School 52 may have maintained the plot.

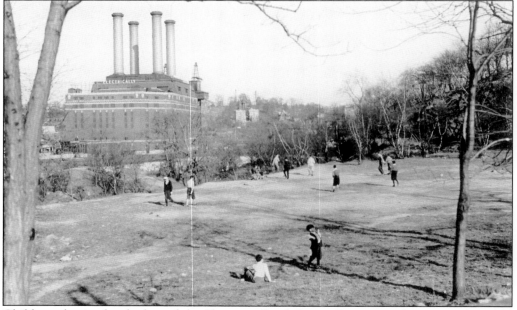

Children play in the shadow of the Sherman Creek Power Generating Station in this 1926 photograph. The eight-story, 62,000-square-foot, coal-burning power station of the United Electric Light & Power Company opened in 1914. The plant was decommissioned in 1970. The behemoth was demolished in 1997 after towering over Inwood for nearly a century.

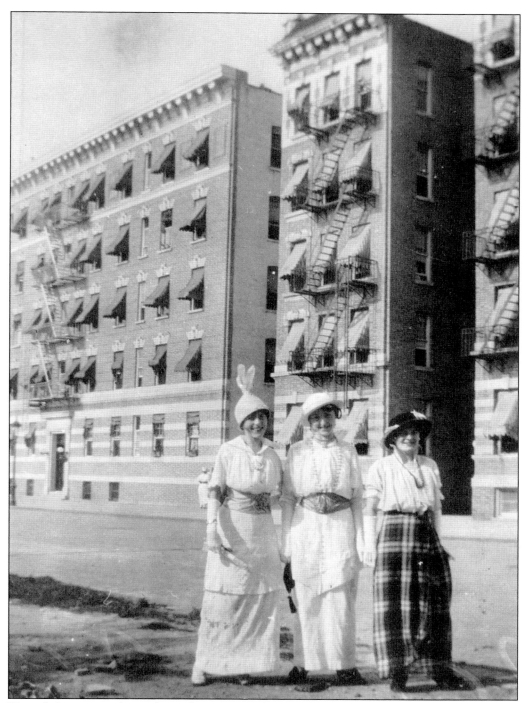

Three ladies pose in front of a newly constructed apartment building at 623 West 204th Street in this 1914 photograph. The awnings helped keep apartments cool before air conditioning. Inwood's first modern apartment houses, the Solano and Monida Apartments, were erected blocks away, on Dyckman Street and Broadway, in 1904.

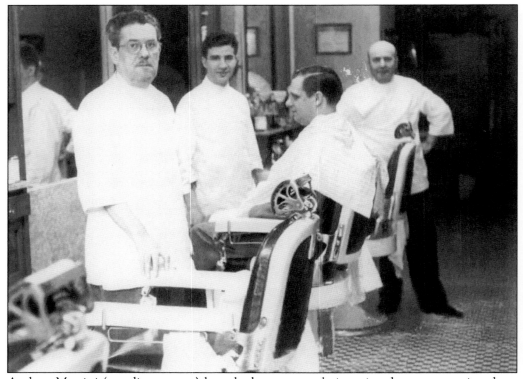

Andrew Mazzini (standing, center) launched an uptown haircutting dynasty spanning three generations when he selected his first set of shears in the early 1930s. The barber's son Ray Sr. and grandson Ray Jr. today both carry on the family tradition. Today, Ray's Barber Shop on West 207th Street near Cooper Street offers classic haircuts in timeless surroundings. (Courtesy of Ray Mazzini.)

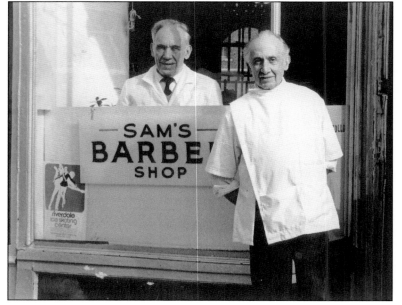

Sam (left) and Charlie Mazzullo proudly pose in front of their barbershop in the 1970s. The brothers' Broadway shop was located across the street from Isham Park. In the shop window is an advertisement for the Riverdale Ice Skating Center on Broadway and West 236th Street. (Courtesy of Ray Mazzini.)

An Inwood youth struts past a barbershop on Sherman Avenue near Academy Street in this 1918 photograph. Despite rapid development in the early 1900s, parents complained that kids had little to do. Children, lacking playgrounds or public facilities, sometimes scavenged upturned cemeteries out of sheer boredom. "The police pay no attention if they don't catch the children parading with skulls on sticks," one mother griped in the *New York Evening Post* on June 21, 1924.

A boy dangles a dead snake on the corner of West 207th Street and Seaman Avenue in this turn-of-the-20th-century photograph. Note the gas streetlight behind the child. Today, blocks away, an identical lamppost, one of only two remaining gas lampposts in Manhattan, survives on the corner of Broadway and West 211th Street. An outcrop of Inwood marble rises behind the intersection.

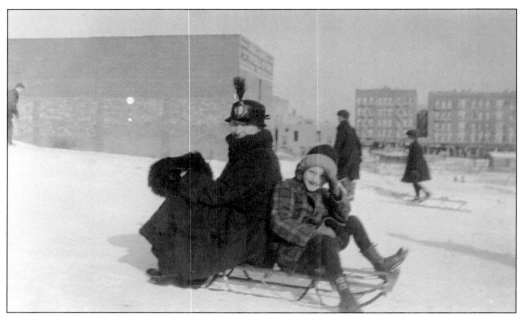

June and Anthony Wheeler share a sled in this winter scene captured on West 204th Street. The region was only partially developed when this photograph was taken around 1915. Notice the empty lots in the background. The downhill slopes of West 204th and West 207th Streets just east of Broadway were popular sledding hills at the time.

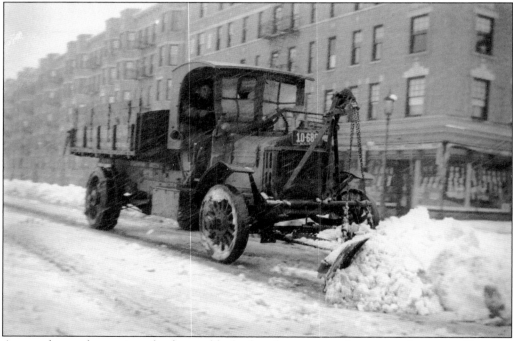

A snowplow pushes a wintry load past a block of newly constructed apartment houses on Sherman Avenue in 1917. The street and nearby Sherman Creek were named after a family who lived in a fisherman's shack at the base of Fort George Hill in the early 1800s.

Anthony Wheeler stands in the middle of a snow-covered Seaman Avenue in this early 1900s photograph. Visible over his shoulders, near today's tennis courts in Inwood Hill Park, is the Church of the Redeemer, an early house of worship that was later absorbed by Holy Trinity Episcopal Church on Seaman Avenue and Cumming Street. In the distance is 666 West 207th Street, a building called the Nethercliffe.

This frigid wintertime snapshot of Sherman Avenue was taken around 1915. In the distance, a lone apartment building stands on West 204th Street. Farther away, the C.K.G. Billings mansion looms atop Fort Tryon. Buildings like the ones seen here contributed to the low-rise look of Inwood's housing stock during the 20th and early 21st centuries.

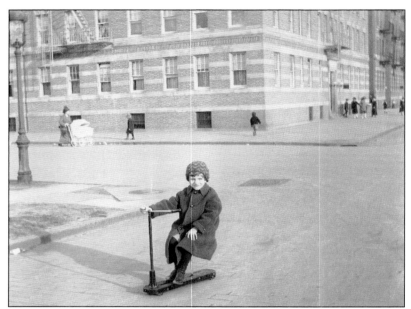

Anthony Wheeler poses proudly atop his scooter near the intersection of West 204th Street and Sherman Avenue in the 1910s. The Wheeler family lived in a rented apartment at 600 West 204th Street, in the background.

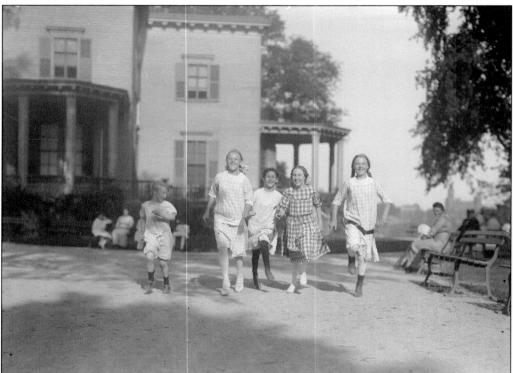

This timeless, undated glass-plate negative shows William Gray Hassler and four unidentified girls running in Isham Park, New York City, around 1911–1914, as onlookers relax on park benches. The Isham mansion is in the background. The Hasslers lived at 150 Vermilyea Street. (Courtesy of the William Davis Hassler Photograph Collection, New-York Historical Society, nyhs_PR83_U01607.)

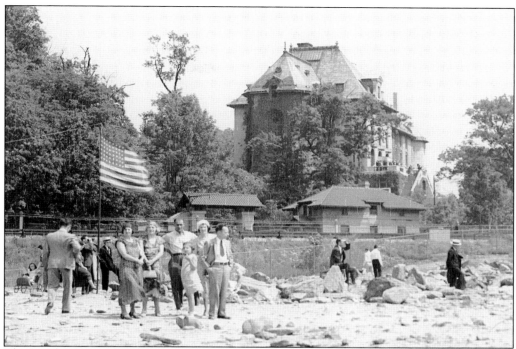

The Jewish Memorial Hospital towers over the surrounding landscape as Inwood residents huddle for this patriotic pose near Dyckman Street. The structure was built to resemble a French château and initially housed the Magdalen Asylum, a home for fallen women. The structure was purchased by the Jewish Memorial Hospital in 1920 and rededicated to the memory of Jewish soldiers who perished during World War I.

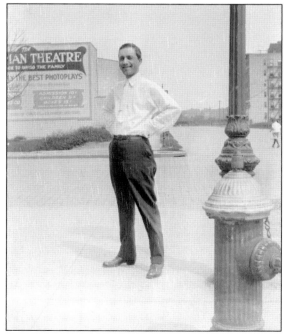

Inwood resident Ezra Wheeler strikes a confident pose at the corner of West 204th Street and Sherman Avenue in this 1914 photograph. The gigantic sign behind him advertises the recently completed Dyckman Theatre, a huge, 1,700-seat silent movie palace that opened on West 207th Street in 1913. The theater entertained generations of Inwood residents until its destruction by fire in 1962. The Wheelers resided in the neighborhood through the early 1920s.

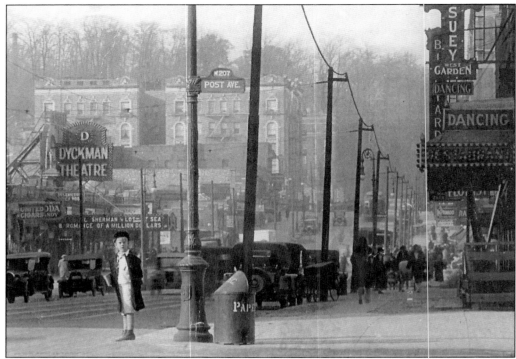

A young lad curiously eyes the photographer in this busy street scene captured on West 207th Street and Post Avenue in 1926. The marquee of the Dyckman Theatre, visible in the background, offers up a double feature of *Romance of a Million Dollars* and *Lost at Sea*. By the late 1920s, West 207th Street, Dyckman Street, and Broadway had become established as Inwood's commercial districts. (Courtesy of Ray Mazzini.)

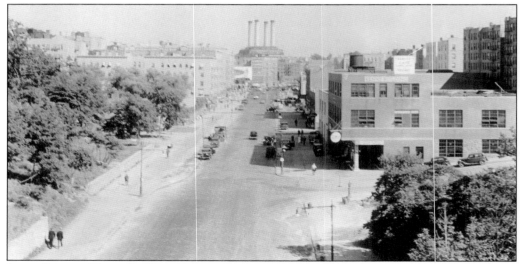

Inwood's iconic Kenny Building, then a service station, is visible to the right in this 1936 bird's-eye view of Dyckman Street near Staff Street. Only two decades earlier, this stretch of Dyckman Street was lined with private homes. Towering in the distance, far to the east, rise the four smokestacks of the old Con Edison power generating station on Sherman Creek.

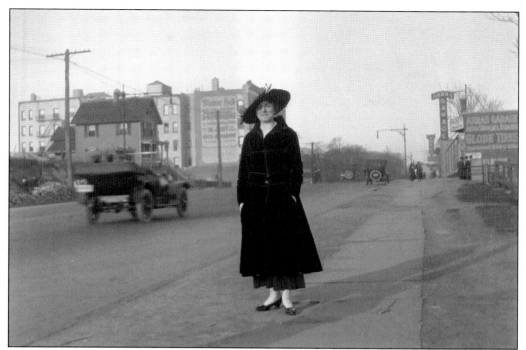

Jane Wheeler stands beside Broadway, south of West 207th Street, around 1918. Behind her to the right are signs for the Arras Garage and Arras Inn. The restaurant was renowned for its fish dinners, particularly lobster. During Prohibition, the Arras Inn was a notorious uptown speakeasy.

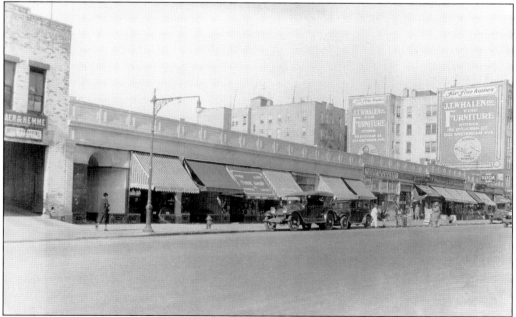

Photographer Percy Louis Sperr captured this Dyckman Street scene in 1927. Storefronts on the commercial strip included the Nathan Strauss Market, Myers Soda and Candy Shop, and an F.W. Woolworth Company five-and-dime.

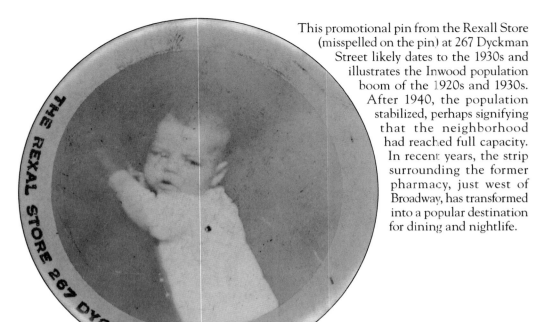

This promotional pin from the Rexall Store (misspelled on the pin) at 267 Dyckman Street likely dates to the 1930s and illustrates the Inwood population boom of the 1920s and 1930s. After 1940, the population stabilized, perhaps signifying that the neighborhood had reached full capacity. In recent years, the strip surrounding the former pharmacy, just west of Broadway, has transformed into a popular destination for dining and nightlife.

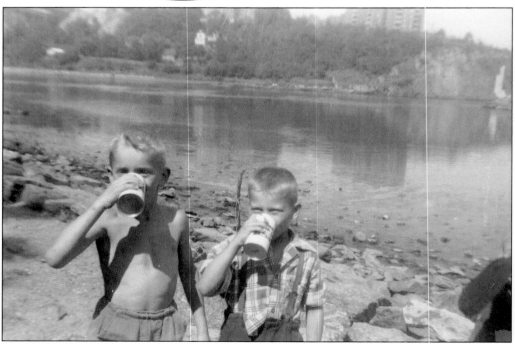

Joe (left) and John Murphy pretend to slake their thirst with ice-cold cans of Rheingold beer in this gag photograph from the 1950s. The duo shared a three-bedroom apartment on Sherman Avenue with six other siblings. Note the partially painted Columbia "C" rock at far right. (Courtesy of Joe Dzinski.)

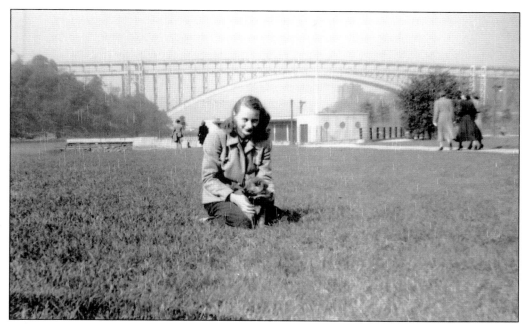

Delores "Dee" Putnam kneels behind her dog Queenie in this 1950 Inwood Hill Park snapshot. Putnam lived at nearby 270 Seaman Avenue. The Inwood Hill Park Nature Center and Henry Hudson Bridge are seen in the background. (Courtesy of Donna Bazal Stone.)

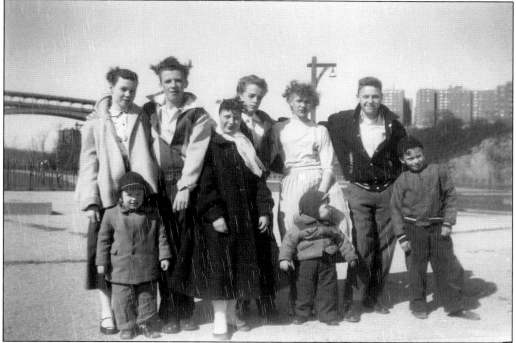

Neighborhood youths gather for a group shot in this delightful 1950s image captured near the present site of the Inwood Hill Park Nature Center. The Henry Hudson Bridge, which opened in 1936, is in the background. (Courtesy of Joe Dzinski.)

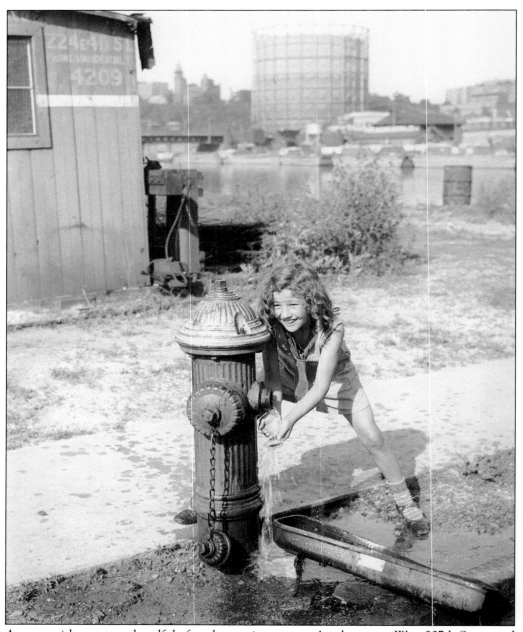

A young girl captures a handful of cool water in a squatter's colony near West 207th Street and the Harlem River in this 1933 photograph. During the Depression, shacks, derelict houseboats, and assorted camps known as "Hoovervilles" dotted the shorelines of both the Harlem and Hudson Rivers. A large cylindrical natural gas storage tank can be seen in the background near the Bronx side of the University Heights Bridge.

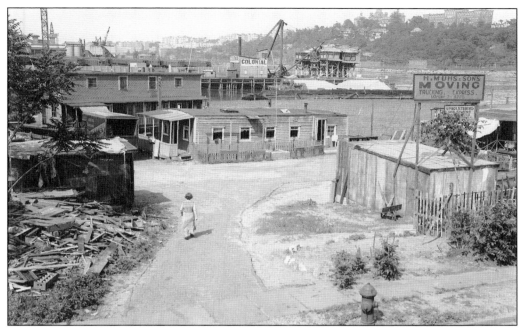

A solitary figure enters a ramshackle squatter's colony on the Harlem River near West 207th Street in this photograph by Percy Loomis Sperr. Many residents maintained gardens, owned dogs and cats, and had access, albeit illegally, to water and electricity. Most stoked coal-fired stoves to stay warm during bitterly cold winters on the waterfront.

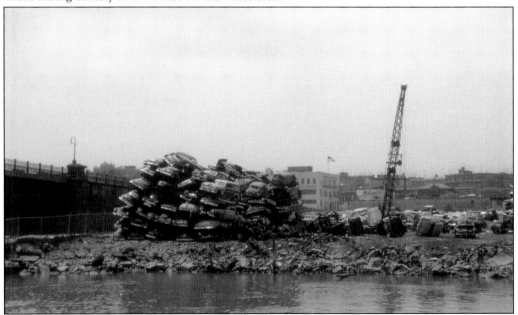

A mountain of junked cars has replaced the squatter's colony on the Harlem River near West 207th Street in this undated photograph probably from the 1950s. In recent years, volunteers have rehabilitated much of the area, called the North Cove. The reclaimed wetlands today attract ducks, geese, and other migratory birds.

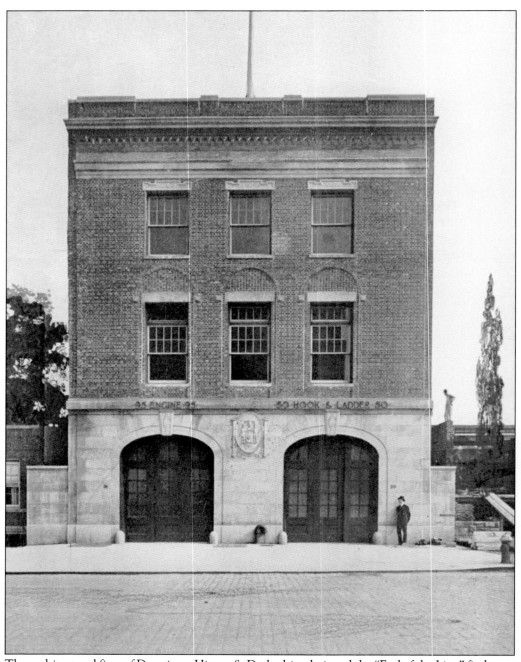

The architectural firm of Dennison, Hirons & Darbyshire designed the "End of the Line" firehouse at 31 Vermilyea Avenue for a cost of $47,000. The 1915 opening of the station was a momentous event for the developing neighborhood. The three-story brick and stone firehouse today houses Engine Company 95 and Ladder 36.

Early Inwood residents demanded protection from runaway fires that plagued the neighborhood. Prior to 1915, the situation was so desperate that Boy Scouts and inmates from local asylums were sometimes enlisted to combat fires.

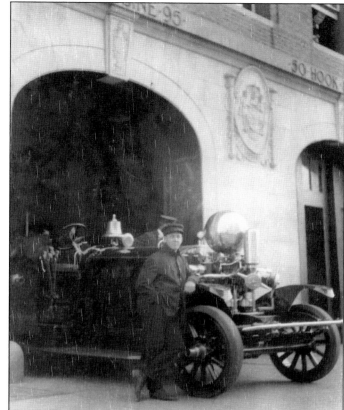

Firefighters from Inwood's Engine Company 95 display their new truck for an admiring crowd. In 2015, the Inwood Fire Department celebrated its centennial. Every summer, the firehouse hosts a block party on Vermilyea Avenue.

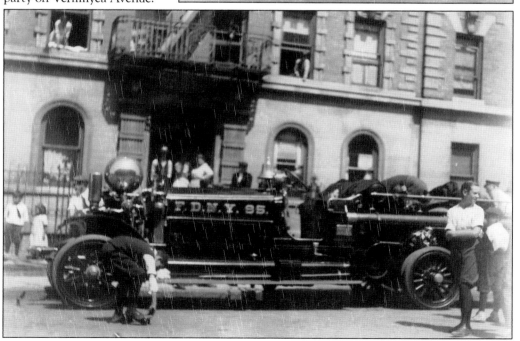

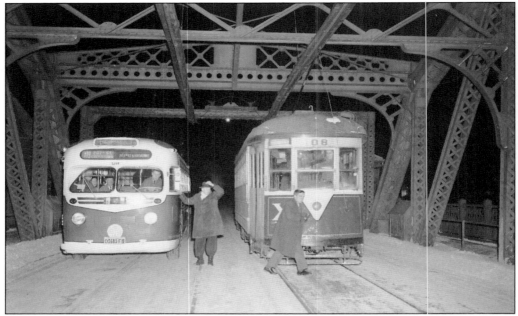

A bittersweet 1948 photograph captures the last crosstown trolley alongside its replacement, a modern bus, as the trolley makes its final run across the University Heights Bridge. The following morning, workers began dismantling the trolley system. The rails and overhead power lines had been a familiar sight in the neighborhood since 1902, when the fare was a mere nickel.

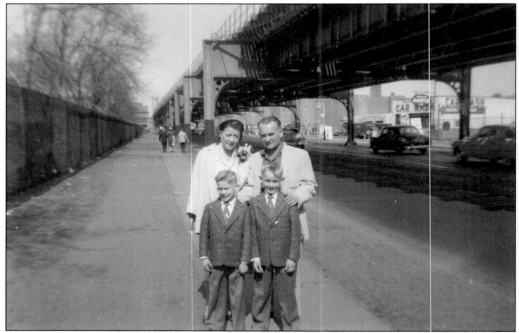

Margaret and Joe Murphy pose with sons John (left) and Joe beneath the elevated subway tracks near West 218th Street and Broadway in the 1950s. Baker Field's fence line is to the left. To the right, a car wash is visible. It was still operating in 2018. (Courtesy of Joe Dzinski.)

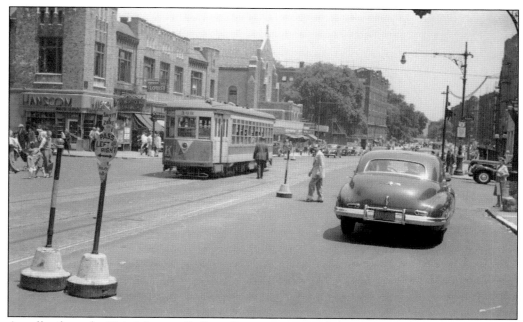

A trolley from the Third Avenue Railway System is captured plying its way down Broadway near West 207th Street in this 1940s photograph. The Church of the Good Shepherd can be seen in the distance. Trolley service was discontinued in 1948. In 2012, a fire destroyed the building to the left.

Mary Morris O'Reilly stands in front of the "White Rocks" on West 204th Street after attending Easter Sunday mass at St. Jude's church around 1957. The White Rocks, as they were called, were outcrops of 500-million-year-old Inwood marble, the bedrock beneath many of Inwood's original hillsides. In 2018, the last gigantic White Rocks outcrops were along Cooper Street between West 204th and West 207th Streets. (Courtesy of Shelia Kramer.)

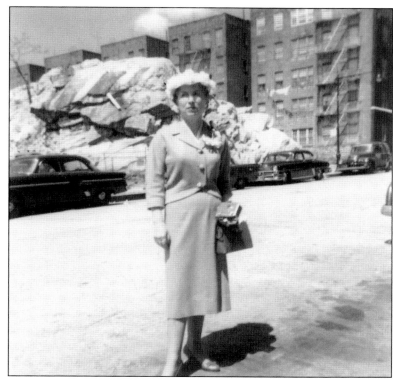

Dyckman St. Ferry

VEHICLE RATES

ALL PLEASURE AUTOMOBILES
(Including Occupants)

25¢

Bicycle	10¢
Motorcycle — two-wheel	10¢
Motorcycle — with side-car . . .	15¢
Trucks—up to 2 ton capacity .	30¢
Trucks—more than two ton and up to 5 ton capacity . . .	50¢
Trucks—more than 5 ton capacity	75¢

Height Limit—11 ft. 6 in.

Foot Passengers 05¢

FREQUENT SERVICE
6 A.M. to MIDNIGHT

When the Dyckman Street Ferry began service to New Jersey in 1915, the fare for a foot passenger was 3¢. The price was quickly rounded up to a nickel. Initially, motorcars were pushed on and off the ferries to prevent backfiring engines from spooking horses, which were still a popular mode of transportation.

The faint outline of the George Washington Bridge is visible in the background of this 1930s snapshot captured by a passenger aboard the Dyckman Street Ferry. When the ferry opened, day-trippers in new-fangled automobiles were able to access the parks and pleasure grounds of New Jersey decades before the construction of the George Washington Bridge.

The ferry was a success from the beginning. On hot summer evenings, passengers often took the ferry back and forth as they gossiped and sang, with the cool river breezes refreshing both body and spirit. Musicians, who paid a concession fee to perform on the boats, did much to enliven the mood. Ferry advertisements promised "a picnic for a nickel."

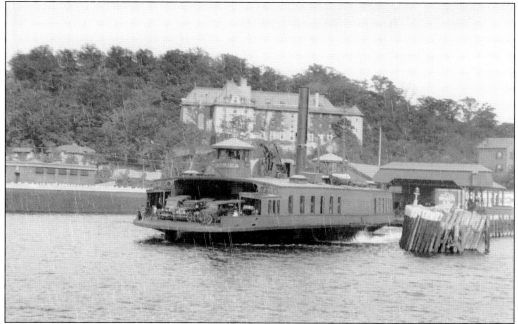

A Hudson River ferry nears the Dyckman Street terminal in this 1934 photograph. The Jewish Memorial Hospital sits perched atop Inwood Hill in the background. Ferry traffic began to dwindle when the George Washington Bridge opened in 1931, and service was discontinued in 1942.

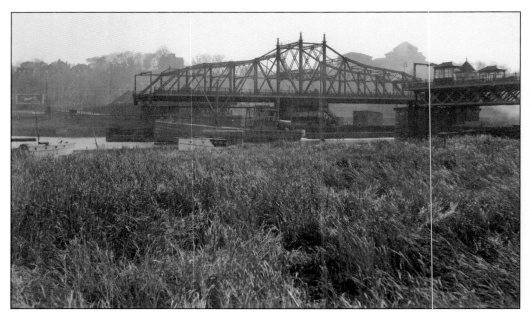

The University Heights Bridge at West 207th Street swings open to allow passage for a boat on the Harlem River in the early 20th century. In later decades, shantytowns and junkyards marred the pristine marshland in the foreground. The area, called the North Cove, has been rehabilitated in recent years.

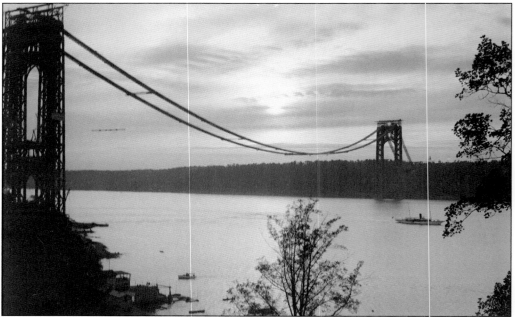

This vertigo-inducing sunset image of the George Washington Bridge was captured in 1930 before workers laid a roadbed across the span. Construction began in 1927, and the new bridge opened on October 24, 1931. The following year, 5.5 million vehicles traveled across the bridge. In 2016, annual usage topped 103 million vehicles, making it the busiest bridge in the world. A lower deck was completed in August 1962.

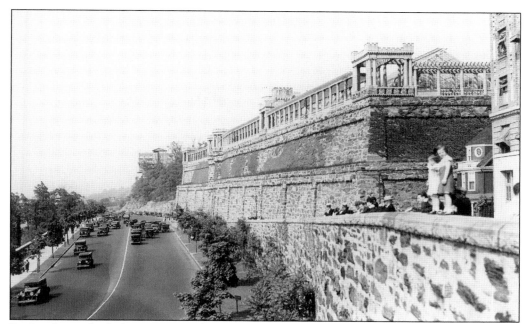

Perilously perched playmates stand on the retaining wall beside the recently opened Henry Hudson Parkway in this 1930s photograph. The massive colonnade behind them belonged to Paterno Castle, the lavish estate of Dr. Charles V. Paterno. The four-story castle occupied seven acres above the Hudson River. A large section of the wall collapsed in 2005 and was later rebuilt. Castle Village Apartments, a housing cooperative, now stands on the site.

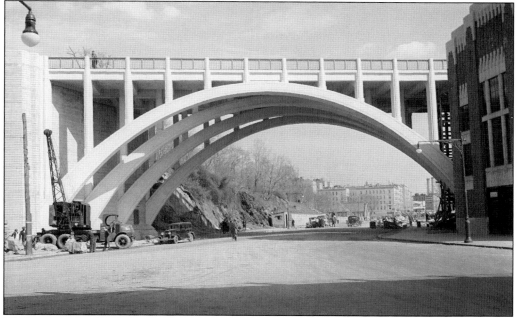

Workers put the finishing touches on the Dyckman Street Viaduct in this 1936 photograph by Percy Loomis Sperr. The graceful Art Deco curves of the concrete span today support the Henry Hudson Parkway above. The viaduct was completed in 1937.

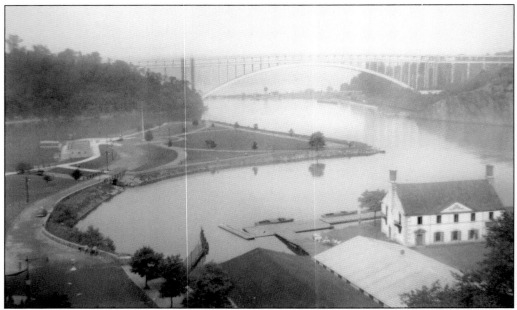

This stunning Spuyten Duyvil photograph was taken in 1950 from the rooftop of 270 Seaman Avenue. The building's supers, Arthur and Margaret Putnam, were photography enthusiasts and captured countless Inwood images in the 1950s and 1960s. (Courtesy of Donna Bazal Stone.)

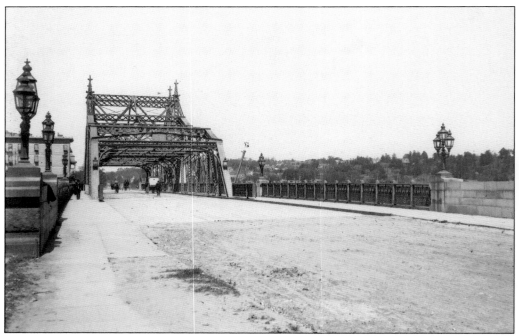

The Broadway Bridge is the star attraction of this turn-of-the-20th-century photograph. Completed in 1895, this elegant span was replaced a mere 10 years later to accommodate the arriving elevated subway tracks. The bridge was floated down the Harlem River to West 207th Street, where it became the University Heights Bridge.

Five

AN UPTOWN OASIS

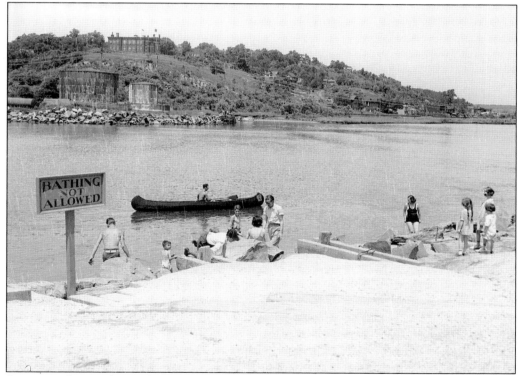

Swimmers disregard a "Bathing Not Allowed" sign in this 1935 image from Inwood Hill Park. In the 1890s, the path of Spuyten Duyvil Creek was altered, and the channel was partially filled to create a ship canal connecting the Harlem and Hudson Rivers. In the 1930s, a final section was modified, allowing marine traffic easier access to Long Island Sound. Today, Circle Line tour boats ply the waterway.

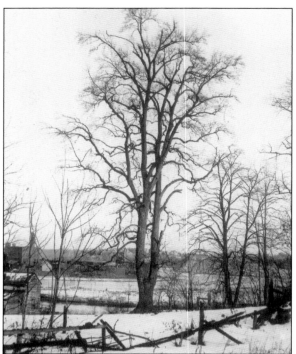

Inwood's famed tulip tree is silhouetted against a wintry backdrop around the turn of the 20th century. The 165-foot-tall *Liriodendron tulipifera* was about 280 years old and in poor health when it was felled by a hurricane in 1938. In 1954, a boulder and bronze plaque were installed at its former base by the American Legion to commemorate the site of Shorakkopoch, a Lenape village.

A fisherman and his dog enjoy a lazy day on an inlet beside Inwood Hill in this 1893 photograph by Ed Wenzel. The home of boathouse keeper Pop Seeley is on the left. Seeley's tranquil cove was covered with landfill in 1936 to create Inwood Hill Park's Gaelic/soccer field.

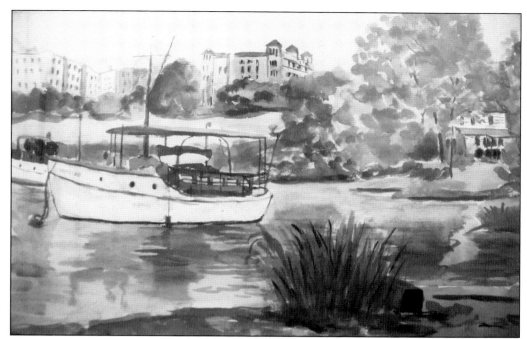

The Inwood Pottery Studio is on the right in this 1932 watercolor by Charlotte Livingston. Aimee LePrince Voorhees and her husband, Harry, founded the studio in 1923 in what would later be Inwood Hill Park. Under the direction of Robert Moses, the pottery works and surrounding houseboat community were evicted from the park in 1936. Voorhees moved the studio to West 168th Street, where she taught until her death in 1951.

Aimee Voorhees found inspiration for her early work in Lenape vessels excavated in nearby archaeological digs. She based this 1920s pot on the vessel discovered at West 214th Street by William Calver in 1906 (see page 10). Examples of her Lenape-inspired pottery are now in the collections of the Newark Museum and the New-York Historical Society. Generations of students, including sculptor Lorrie Goulet, credit her mentorship in guiding their careers.

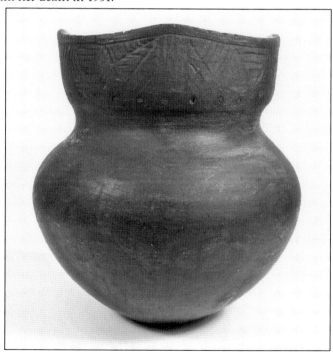

The Columbia University boathouse is at left center in this breathtaking 1939 photograph of Inwood Hill Park. Depression-era work gangs under the direction of Robert Moses improved trails and other park infrastructure during the 1930s. Behind the boathouse is the recently built storefront that today is the home of the Indian Road Cafe, where Lost Inwood local history talks began in 2009.

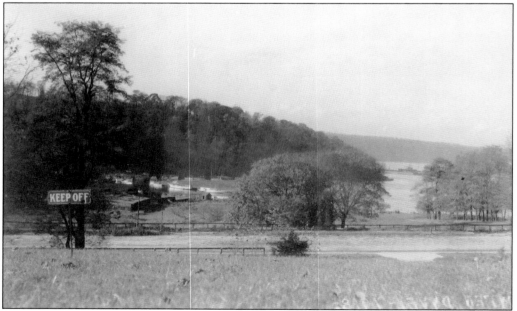

Inwood Hill Park was still private property when this photograph was taken near Seaman Avenue in 1918. The park would not be dedicated until 1926. Actually, the "Keep Off" sign is in the adjacent Isham Park, which opened in 1912. The Henry Hudson Bridge, missing in this photograph, opened in 1936. In the distance, to the west, are the New Jersey Palisades.

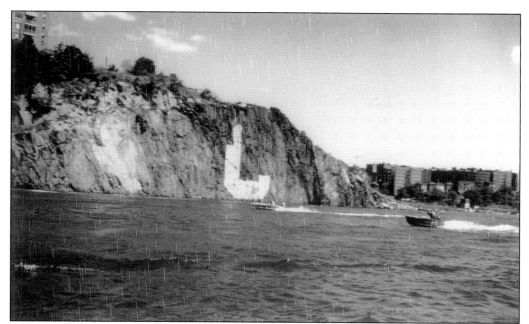

Note the partially painted Columbia "C" in this photograph taken during an "Around Manhattan" speedboat race in 1956. Begun by students around 1954, it took several years to complete. The 60-by-60-foot "C" remains today painted in traffic white and aquamarine blue on the vertical exposure of billion-year-old Fordham gneiss. (Courtesy of Evelyn Ruggiero.)

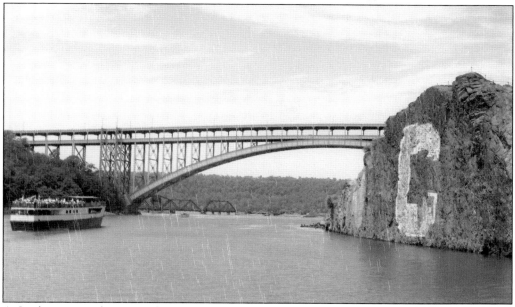

A Circle Line tour boat cuts along the Spuyten Duyvil beside the giant "C" maintained by students of Columbia University. The cliff was featured in the 1995 film *The Basketball Diaries* starring Leonardo DiCaprio. In the movie, several characters dive from the cliff into the turbulent water below, reenacting an enduring neighborhood tradition. Former Isham Street resident Jim Carroll authored the book on which the film was based.

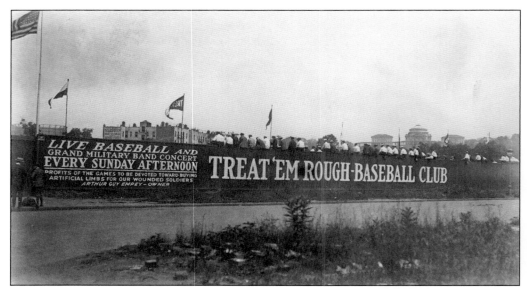

The billboard in this July 4, 1919, photograph promotes the Treat 'em Roughs, a barnstorming celebrity charity baseball team led by war hero Guy Empey. In the early 20th century, the Dyckman Oval, a parks department sporting venue, hosted a wide variety of programming, including pre-integration college and professional sporting events. Today, the Dyckman Houses, a public housing project, occupies the location at Nagle Avenue and Academy Street.

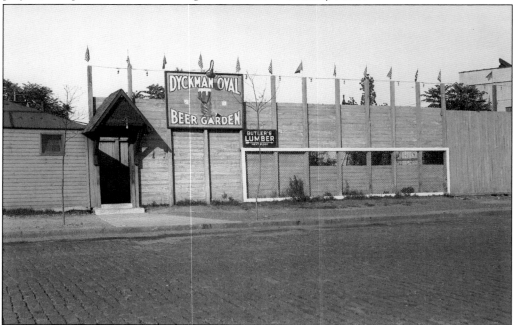

An intoxicatingly persuasive sign outside the Dyckman Oval invites spectators to visit the beer garden in this 1933 photograph. Harlem numbers broker Alejandro Pompez renovated the 10,000-seat arena in 1935, adding floodlights so his Negro League baseball team, the New York Cubans, could play well into the night. Manhattan's first pro-ball night game took place here under the arc lights on Friday, June 7, 1935. The oval was demolished in 1938.

This 1935 Dyckman Oval poster hypes a gridiron matchup between the Morgan College Bears and the Lincoln University Lions. About 5,000 fans attended the football game between the rival African American college teams. From 1935 to 1937, Fritz Pollard's Brown Bombers played professional football here during the NFL's unofficial ban on black athletes. Since 1990, the annual Dyckman Basketball Tournament has taken place on the site.

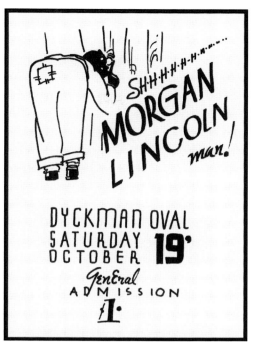

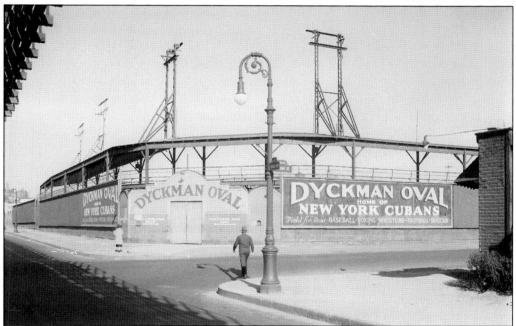

The Dyckman Oval's floodlight supports can be seen in this 1937 photograph. The New York Cubans were the only Negro League team at the time to have their own stadium. The mostly Hispanic players—also ostracized by the major leagues—played here for two seasons. Team owner Alejandro Pompez was inducted into the National Baseball Hall of Fame in 2006. Pompez created the Dominican pipeline that ultimately afforded Latin American players a pathway to the majors.

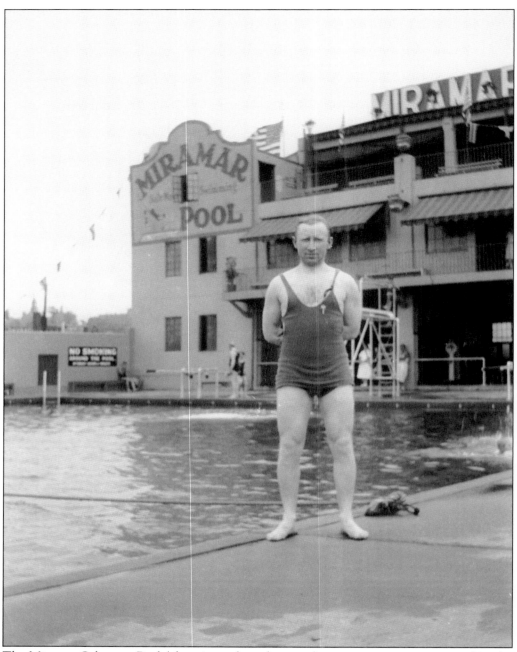

The Miramar Saltwater Pool (also pictured on the cover) was a great way to stay cool in the summer heat. Here, a swimmer prepares for a dip. Bathers were given a locker key (seen pinned to the swimming outfit) after paying admission. Advertisements claimed the facility was the largest saltwater pool in the world. The summertime oasis on West 207th Street and Ninth Avenue operated from the 1920s through the 1960s.

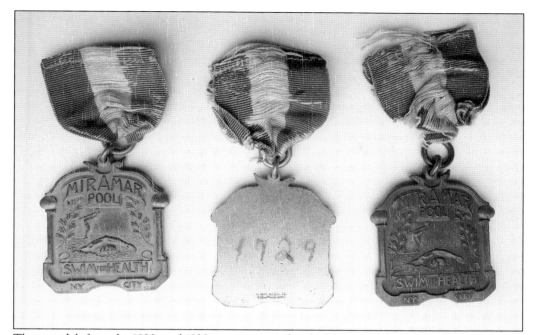

These medals from the 1920s and 1930s were presented at the Miramar Saltwater Pool to participants in swimming and diving competitions. The Miramar closed during the 1960s. A Pathmark grocery store was later built on the site.

A swimmer slides into the cool waters of the Miramar Saltwater Pool in this undated photograph. Pool amenities included diving boards, handball courts, ping-pong tables, and a cafeteria. Former patron Ken Hollerbach recalled a beach area that contained "the dirtiest sand I ever saw; it was full of soot and would get so hot in the sun that you couldn't walk across it barefoot."

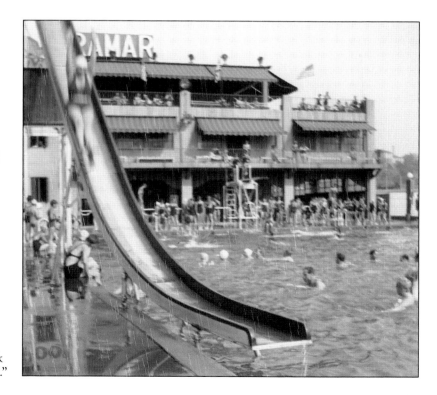

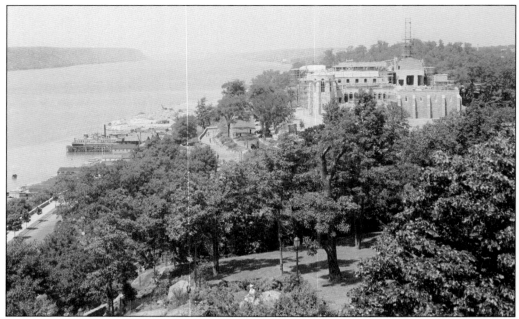

The Cloisters museum in Fort Tryon Park is seen under construction in this stunning Hudson River scene captured in 1937. Sculptor and art dealer George Grey Barnard's vast personal collection of medieval art became the foundation of the museum's collection, which opened in 1938. In the distance, landfill can be seen being deposited at the Hudson River's edge to create additional acreage for the Dyckman ball fields.

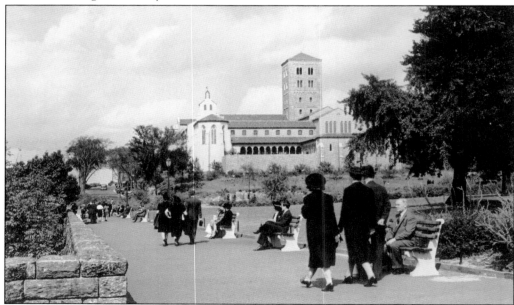

Frederick Law Olmsted Jr., whose father helped design Central Park, laid out the idyllic paths, promenades, and terraces that make Fort Tryon such a special place. Olmsted was said to have been in awe of the park's unspoiled views of the Hudson River and New Jersey Palisades to the west. This 1938 photograph was taken just as the Cloisters museum was opened to the public.

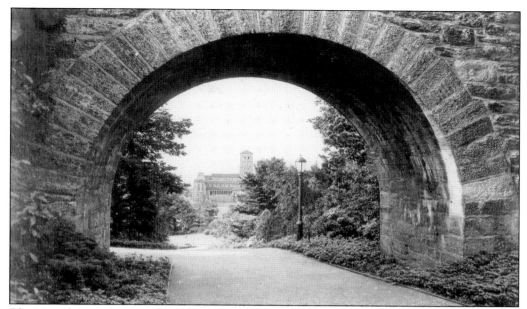

The Met Cloisters are seen through the arched frame of a stone overpass in Fort Tryon Park. This uptown branch of the Metropolitan Museum of Art incorporates portions of five medieval abbeys: Saint-Guilhem-le-Désert, Trie-sur-Baïse, Saint-Michel-de-Cuxa, Froville, and possible details from Bonnefont-en-Comminges. The five cloisters were dismantled in France and reassembled in New York.

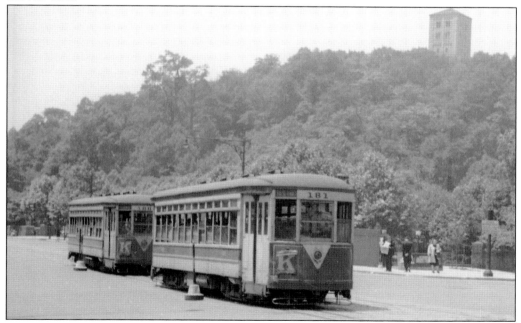

An uptown trolley on the Broadway line near Dyckman Street in the 1940s. The tower of the Met Cloisters museum is at upper right. The ancient stone structures, their materials sourced from European monasteries and stocked with medieval art, were designated an official New York City landmark in 1974.

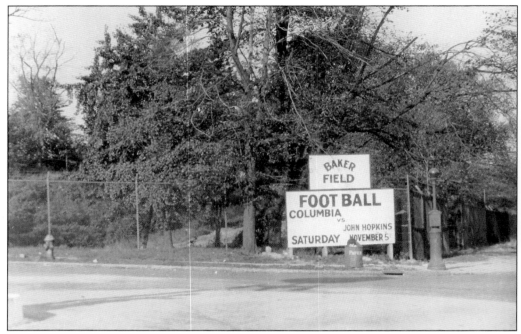

A sign on West 218th Street and Broadway announces a November 5, 1927, matchup between Columbia and Johns Hopkins Universities at nearby Baker Field. The game ended in a tie, 7-7. Columbia's now sprawling athletic complex hosted its first football game in 1923.

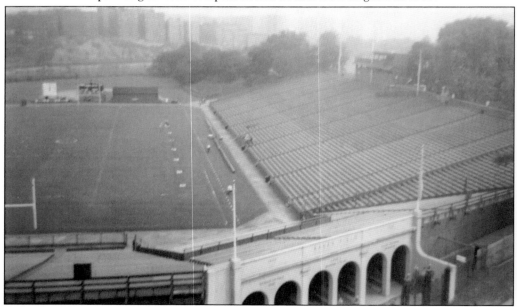

Columbia University constructed this 32,000-seat wooden stadium in 1928. The old gridiron remained a familiar landmark for 55 years. This photograph was taken from an apartment window at 270 Seaman Avenue in 1937. The arched entrance to the stadium was at the foot of Seaman Avenue on West 218th Street. The athletic field was demolished in 1983 and replaced by the 17,000 seat Lawrence A. Wien Stadium, which opened in 1984.

Several young Baker Field score changers shuttle signs behind the scoreboard while another worker watches the game from his perch in this 1948 photograph. That same year, Dwight D. Eisenhower was appointed the 13th president of Columbia University. Eisenhower was sworn in as the 34th president of the United States in 1953.

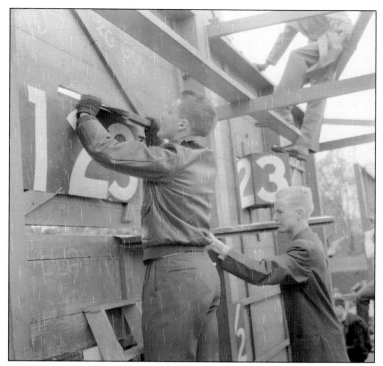

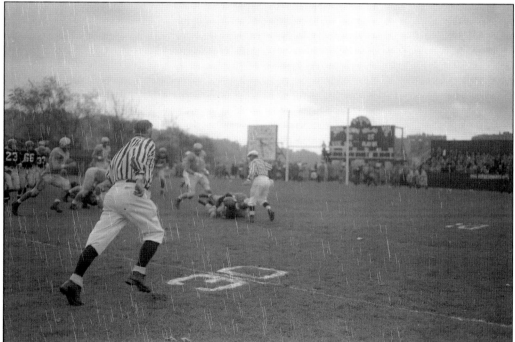

A referee races to a tackle in this 1948 matchup between home team Columbia University and Princeton University at Baker Field. Princeton's Tigers defeated Columbia's Lions with a final score of 16 to 14. Official game day programs were 35¢.

It is hard to imagine New York City without a public library system, but until 1895 that was the case—communities had to fend for themselves when it came to literacy. In 1860, neighborhood residents founded the Dyckman Library, a free lending library open to all. By the early 1900s, the library was housed in the Flitner residence at 17 Bolton Road. The home, pictured here, was within today's Inwood Hill Park.

In response to a local petition, the New York Public Library opened a small subbranch in 1922. This temporary storefront library at 190 Sherman Avenue on the corner of West 204th Street operated until 1928. The location was later the site of St. Matthew's Lutheran School. Today, Public School 366 occupies the site of the former library in a new building. (Courtesy of NYPL.)

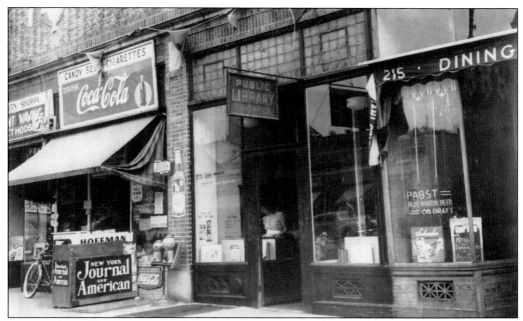

From 1928 to 1951, the itinerant library found refuge inside this storefront at 215 Sherman Avenue between West 207th and West 204th Streets, sandwiched between soda shops, diners, and taverns. Records from this time show head librarians asking for books in many different languages to accommodate the reading needs of the new, often immigrant population. (Courtesy of NYPL.)

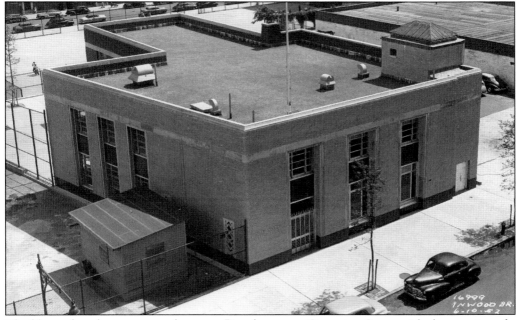

The library found a permanent home on Broadway near Cumming Street with the opening of a New York Public Library branch in 1952. In 2017, plans for a new library were announced. The new facility is to be named Eliza—in honor of Eliza Hamilton, whose creation of the Hamilton Free School in 1818 was a driving force for literacy in early Inwood. (Courtesy of NYPL.)

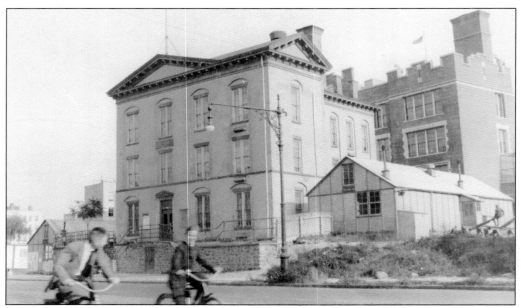

Two cyclists cruise past the original Public School 52. The region was farmland when Isaac Dyckman donated the land on which the brick schoolhouse was built in 1858. The Dyckmans also helped found the Hamilton Free School near West 189th Street in 1818—funds from which continue to support uptown education in the form of Dyckman Institute Scholarships at Columbia University. This schoolhouse was demolished in 1956.

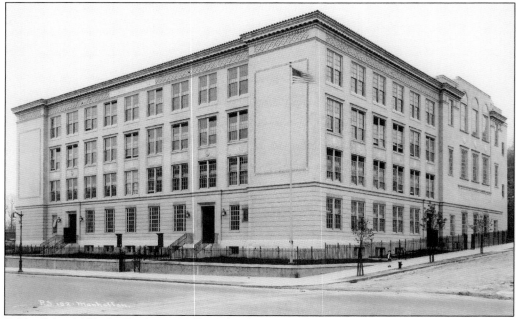

Public School 152, the Dyckman Valley School, at 93 Nagle Avenue between Sickles and Ellwood Streets, was erected in 1927. In the 1950s and 1960s, teacher Sylvia Kerasik's fifth- and sixth-grade classes wrote impressive histories of the neighborhood titled *The Dyckman Valley Yesterday and Today*. The essays are housed in the Millstein Division of the New York Public Library.

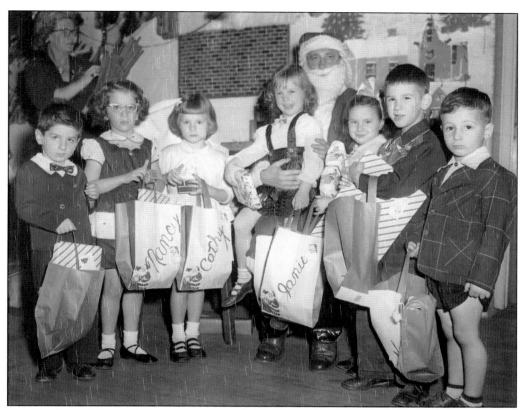

Neighborhood kids try their best to smile for the camera at a 1953 Christmas party inside the Payson Playground Nursery School. The playground and comfort station opened near Dyckman Street and Payson Avenue in 1934. (Courtesy of Evelyn Ruggiero.)

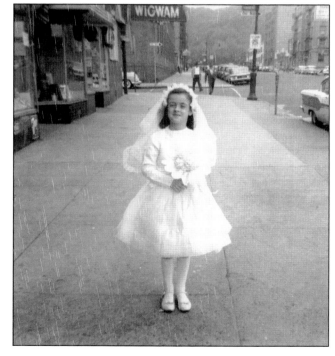

An angelic Donna Gray grins for the camera on the day of her first communion in this touching 1960 photograph. A neon sign for the Wigwam Inn, a popular pub on Sherman Avenue, beckons in the background. Inwood residents have three Roman Catholic churches to choose from: Good Shepherd on Broadway, Our Lady Queen of Martyrs on Arden Street, and Saint Jude's on Tenth Avenue. (Courtesy of Claire Anne Gray.)

Tziporah Heckleman, a student at the Jewish Theological Seminary's Teachers Institute (class of 1950), instructs a group of boys at the Inwood Hebrew Congregation, a conservative synagogue at 111 Vermilyea Avenue, in this late 1940s photograph. (Courtesy of the Library of the Jewish Theological Seminary.)

INWOOD HEBREW CONGREGATIONAL SCHOOL

Under the Direction of the
JEWISH THEOLOGICAL SEMINARY OF AMERICA

An afternoon Hebrew school for the American-Jewish boy and girl, which aims to help the child grow up to become an effective member of the American-Jewish community. All Jewish parents are urged to enroll their children **now** for the new term.

III VERMILYEA AVENUE	LO. 8-3282

Inwood became a haven for European refugees in the years surrounding World War II. Synagogues played an important role in helping immigrants adjust to their new environment. This 1948 advertisement was placed in a publication called the *Inwood Chatter*, a booster magazine once published by Public School 52. A few blocks south, at 4624 Broadway, the Congregation Ohav Sholaum, an orthodox synagogue, operated from 1940 to 2006.

Perhaps nothing symbolizes Inwood's ever-evolving demographics more clearly than this former Vermilyea Avenue synagogue, now a church. Hundreds attended services when the Inwood Hebrew Congregation opened in the 1920s. But, after decades of declining attendance, the building was sold to the Seventh-Day Adventist Church in 1996. Initially, the two groups shared the space. When the Hebrew Congregation ceased services in 2005, its six Torah scrolls were donated to synagogues around the world.

The original Jewish Memorial Hospital, seen here in 1934, was located on Dyckman Street not far from the Hudson River. The facility, a former asylum for wayward girls, was dedicated to the memory of Jewish soldiers who perished during World War I. The hospital would later relocate to Broadway and West 196th Street.

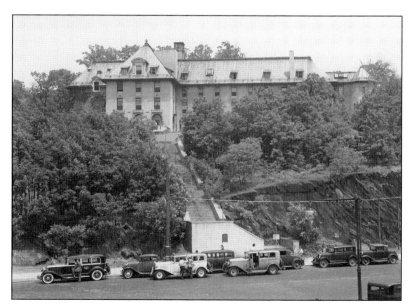

The former home of William and Minnie Hurst is seen on the corner of Park Terrace East and West 215th Street in this photograph from the early 1920s. Hurst was president of the Stock Quotation Telegraph Company and served as the grand jury foreman for the Triangle Shirtwaist Factory fire inquiry. The Isham Gardens apartments, then under construction, are visible in the background. (Courtesy of JoAnn Jones.)

This portrait of the Hurst family was taken outside their brick three-story home on Park Terrace East in 1924. The institutional-style residence was designed by noted architect James O'Connor to accommodate Hurst's 16 children from two wives. The home has been bricked up since the 1980s after a fire destroyed part of the entryway. (Courtesy of Hurst family.)

Students from the Gerard School are all smiles on their 1959 Confirmation Day. The private school for girls occupied the former home of William H. Hurst. Students recall a grand entryway that featured a black-and-white tiled floor, sweeping double staircases, and a chandelier. (Courtesy of Evelyn Ruggiero.)

Students of the Gerard School wait in a lunch line in 1960 in the Sacred Heart of Mary cafeteria. The redbrick school for girls on Park Terrace East and West 215th Street occupied the former residence of William H. Hurst. Pictured from front to rear are Severine Grieb, Eileen Murphy, Janice Yankay, and Evelyn Strobel. (Courtesy of Evelyn Ruggiero.)

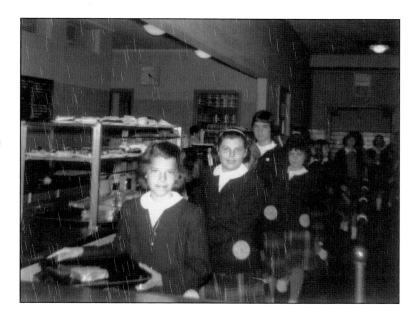

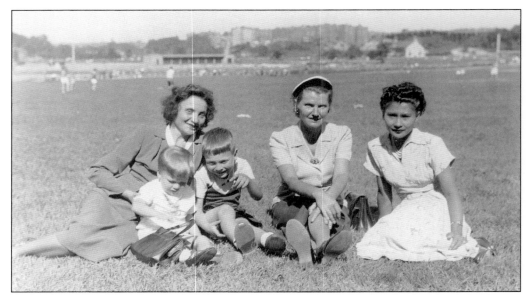

German American Emma Maruska (left) spent World War II in a Texas internment camp after being designated an enemy alien. Her oldest son, Herb (right), was born at the camp. Vermilyea Avenue neighbor Fe Palafox (far right) was from the Philippines. The Palafoxes, fearful of hostility and accidental internment, wore signs reading "We are not Japanese" whenever outside. Also pictured is German-speaking immigrant Martha Culkin from Alsace-Lorraine. (Courtesy of Herb Maruska.)

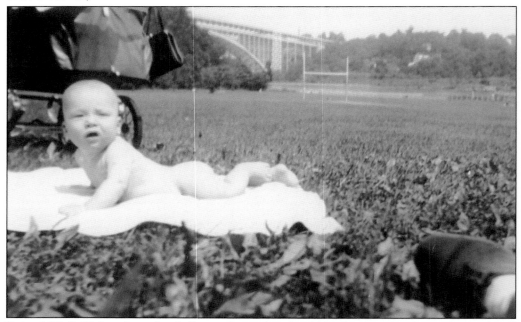

Roland "Rolly" Maruska is decidedly unashamed in this 1948 photograph taken in Inwood Hill Park. When the Maruskas were released from internment at the conclusion of the war, they moved into a rented apartment on Vermilyea Avenue near West 207th Street. (Courtesy of Herb Maruska.)

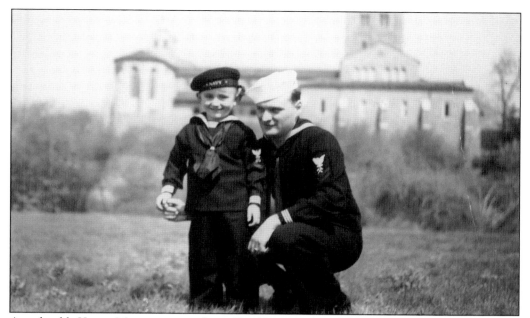

An adorable Kenny Mason enjoys a day in Fort Tryon Park with his uncle Charles Strobel in this World War II era photograph. The Cloisters, a medieval-style castle and museum, rises from the hill in the background. (Courtesy of Evelyn Ruggiero.)

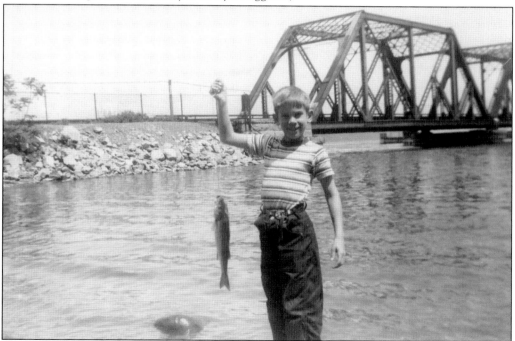

Former Inwood resident Ken Unger proudly displays his catch beside the Spuyten Duyvil railroad bridge in the 1950s. Locals called this rocky shore "Bare Ass Beach." The steel bridge was constructed in 1900 to replace a wooden drawbridge that had been there since the late 1840s. (Courtesy of Bob Unger.)

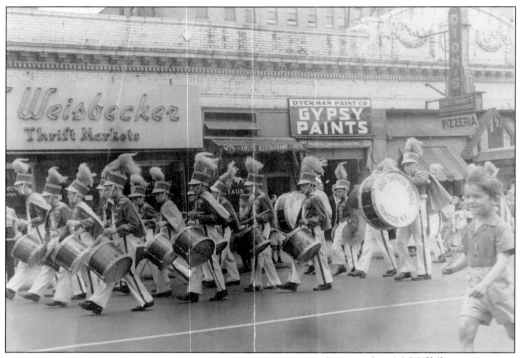

A young Jim McNiff (bottom right) runs alongside a drum corps from the Good Shepherd School on Memorial Day 1941. In the background, Dion's Dyckman Street pizzeria offers "dining and dancing—no cover charge." (Courtesy of Claire Anne Gray.)

Young Anthony Wheeler sits beside his uncle Fritz Klem at the base of the West 215th Street Staircase in 1918. The staircase connects Broadway with Park Terrace East, 63 feet above. It was completely rebuilt in 2015. Northern Manhattan's topography is sometimes too steep for cars. To make those places accessible to pedestrians, staircases were built. Another step street, along West 214th Street, connects Seaman Avenue and Park Terrace West.

Newly installed windows are visible as construction of the Dyckman public housing complex nears completion. The seven 14-story buildings were opened to residents in 1951. The 14-acre site was once the location of the Dyckman Oval stadium; today, the location of its old home plate is covered by a parking lot.

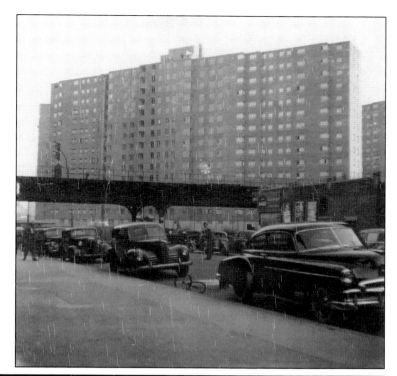

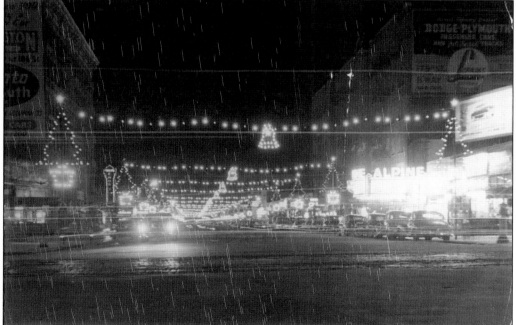

A festive display of holiday lights enlivens the corner of Dyckman Street and Broadway in this nighttime photograph from the 1950s. Hiding in the background of this visual spectacle are the Alpine Theater (right) and the popular Hi-Ho Chinese Restaurant (left). Inwood's first apartment buildings, the Solano and Monida, are on the left. (Courtesy of Claire Ann Gray.)

Tommy Collentine (rear left) and other longshoremen pose for this rare photograph beside Neville's Bar on Dyckman Street during World War II. The North River hiring boss was gunned down on the sidewalk in front of his 39 Post Avenue apartment building in 1948. Collentine's gangland-style assassination sparked the newspaper investigation that served as the framework for *On the Waterfront*. This is the only known photograph of Collentine. (Courtesy of Patricia Farrell.)

Mary Murphy smiles for the camera atop a wall near the West 207th Street entrance of Inwood Hill Park along Seaman Avenue. Murphy shared her three-bedroom apartment inside 124 Sherman Avenue with seven siblings. (Courtesy of Joe Dzinski.)

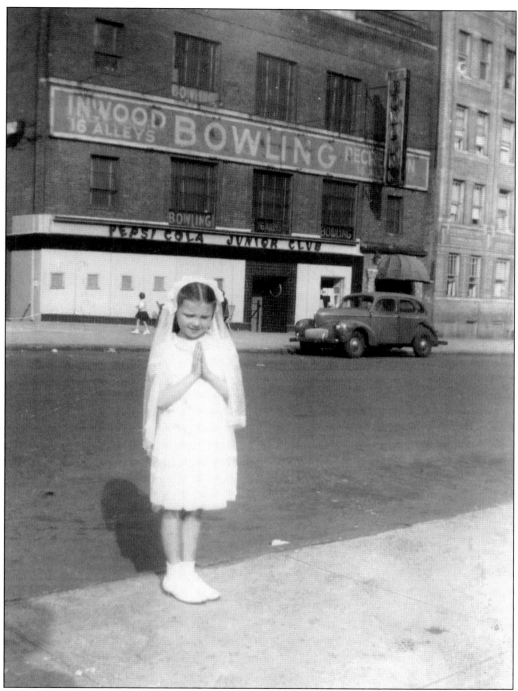

This darling photograph of Patricia Farrell in her first communion dress was taken on Academy Street across from Public School 52 in 1945. Behind her are the Pepsi-Cola Junior Club and a bowling alley. The Pepsi-Cola Junior Club was a kid-friendly gathering place with a soda fountain, snacks, and a jukebox for dancing. (Courtesy of Patricia Farrell.)

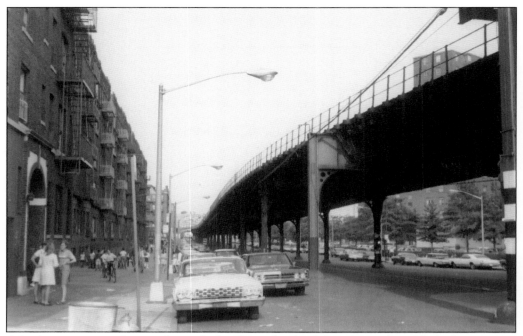

A lively street scene plays out beneath the elevated rails of the subway along Nagle Avenue near Dyckman Street in 1967. The Dyckman public housing complex can just barely be seen on the right. This view remained virtually unchanged in 2018. (Courtesy of Steven Unger.)

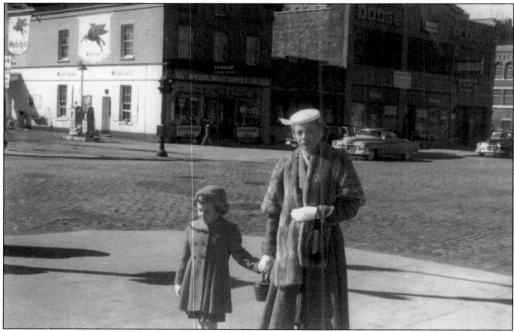

Evelyn Ruggiero holds her mother's white-gloved hand in this tender image captured on the corner of Seaman and Payson Avenues in the 1950s. The general store once owned by Robert Veitch is at far left. The sign reads "Inwood Boat Supply Co." (Courtesy of Evelyn Ruggiero.)

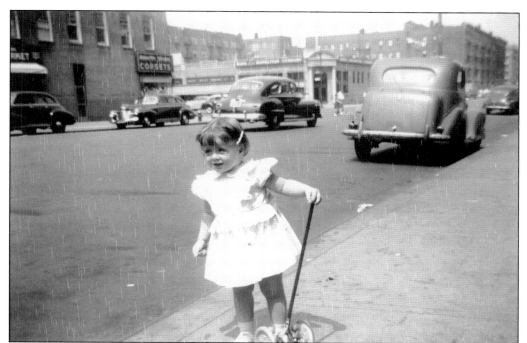

Claire Anne Gray takes her corn-popper push toy for a stroll down Sherman Avenue in 1950. In the background, across the intersection, the arched entrance and columns of 161 Dyckman Street, now a Chase bank, are visible. The classic architectural features were demolished during later renovations. (Courtesy of Claire Anne Gray.)

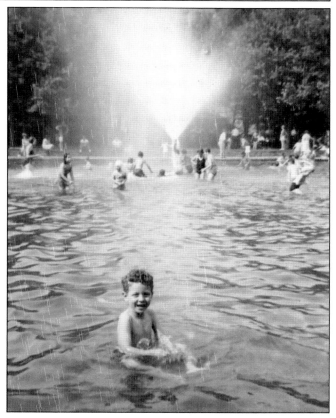

Four-year-old Larry Lief splashes in the pool of Fort Tryon's Anne Loftus Playground in this 1947 photograph. Larry's family lived nearby in a courtyard-level apartment at 15 Seaman Avenue. Lief recalled, "I remember how sad I was a year or so later when they stopped filling the pool up to the rim." Lief left the neighborhood in 1961 after joining the Navy. (Courtesy of Larry Lief.)

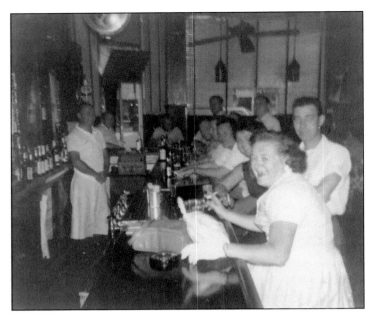

Inwood steelworker Reynold "Renny" Mahlau picks up a bartending shift at Garryowen's Lounge in 1962. A former patron remembers a peculiar hangover remedy favored by the German barkeep. "He'd send a kid across the street to the pork store for a pint of sauerkraut juice," recalled Richard Scaravella. Frances Gray, sporting a white dress and matching gloves, smiles from the head of the bar. (Courtesy of Claire Anne Gray.)

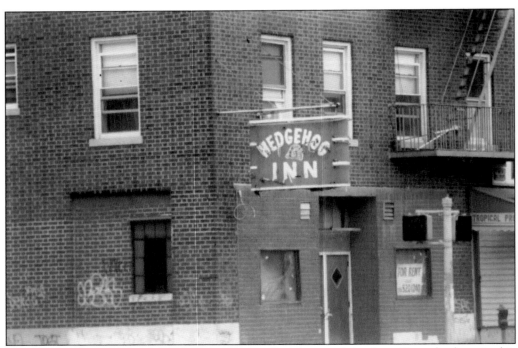

The white and green sign of the Hedgehog Inn on Broadway and Academy Street beckons in this undated photograph. "I remember the Hedgehog in its final days," recalls former patron James Kushner. "It was a real dive, surpassed only by the Lakes of Killarney." Other taverns included Nugent's, Markey's, Chambers, the Sloop, and the Inwood Lounge. (Courtesy of Donna Gray.)

By the early 2000s, the number of Irish pubs had dwindled to a mere handful. Changing demographics, high rents, and evolving attitudes toward drinking forced many familiar taverns to shut off their taps and close their doors. The Irish Brigade, on Broadway and Arden Street, closed in 2016.

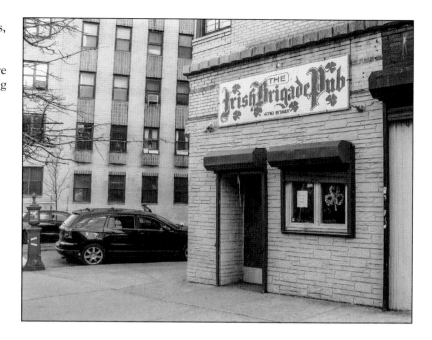

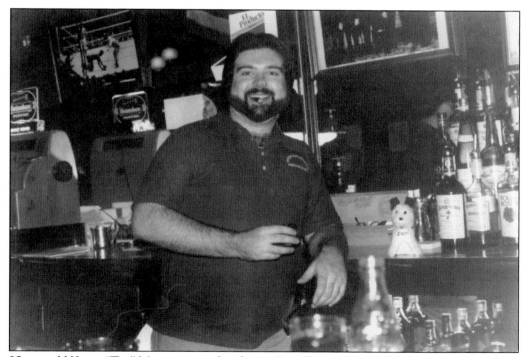

25-year-old Kevin "Tex" Mooney is tending bar at Costello's on West 207th Street and Broadway in 1979. As a teen playing football in Inwood Hill Park, friend Bobby O'Shea commented that the bruising fullback was hard to tackle—because he was big, "like the state of Texas." Mooney has never set foot in the Lone Star state. (Courtesy of Kevin "Tex" Mooney.)

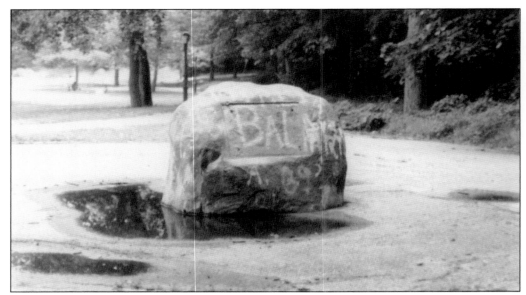

This photograph of a vandalized Shorakkopoch Rock in Inwood Hill Park was taken in 1970 as the City of New York was facing bankruptcy. Local residents complained of deplorable conditions in city parks. In November 1971, National Guardsmen were deployed in Inwood Hill Park to help a short-staffed parks department clear dead trees and trash. The missing plaque, since replaced, describes Peter Minuit's alleged "purchase" of Manhattan Island from the Lenape. (Courtesy of Herb Maruska.)

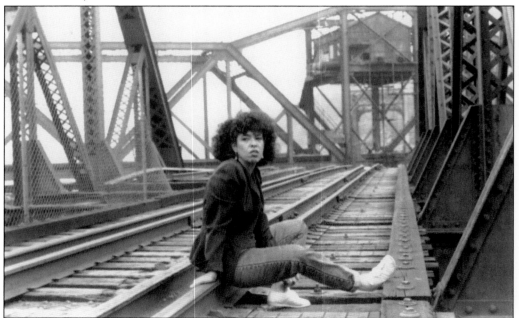

Migdalia Santos trains her eyes on the lens in this image captured on the Spuyten Duyvil railroad swing bridge in 1985. The tracks follow the route of the first rail service into Manhattan from the mainland. The span has endured periodic damage by tides and weather since its construction in the mid-1800s. It was substantially overhauled in 2018. (Courtesy of Migdalia Santos.)

Imagine a slice of pizza for only 20¢. Steven Unger took this photograph of a pizzeria at 139 Dyckman Street in 1967 before heading to college. Unger grew up in the Dyckman Houses with Lew Alcindor, who achieved basketball fame as Kareem Abdul-Jabbar. (Courtesy of Steven Unger.)

Sylvester "Mooch" Donohue mugs for the camera aboard the good ship *Rock N Roll* in front of the Val-Ray Boat Club on the Harlem River. Donohue served as the Dyckman Street club's commodore during the 1950s when this photograph was taken. Mooch lived on Academy Street until his death in 1972. (Courtesy of Lois Hughes.)

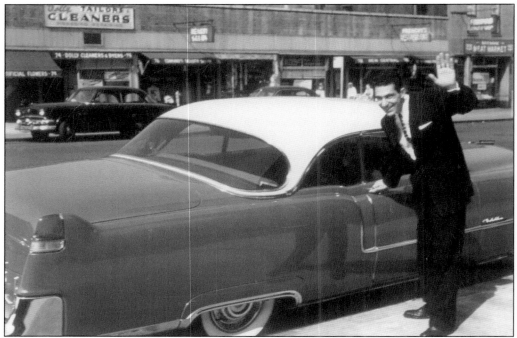

A dapper Joe Barbieri waves for the camera beside a shiny red Cadillac on Dyckman Street in 1956. The row of businesses in the background includes Frenchy's Restaurant, a beauty salon, a florist, dry cleaners, and a meat market. (Courtesy of Claire Anne Gray.)

The Alpine movie theater sat on the south side of Dyckman Street around the corner from Broadway. As the decades ticked by, generations of Inwood residents flocked here to watch classics like *Flash Gordon*, *Saturday Night Fever*, *Jaws*, *E.T.*, and *Rocky*. For decades, Inwood had three movie theaters. The Alpine, the last remaining, went dark in the 1980s. (Courtesy of Claire Anne Gray.)

An enigmatic man in black seems lost in thought in this wintry moment captured on Seaman Avenue near West 218th Street in 1963. Today, the avenue, off Inwood Hill Park, is a mix of rental and cooperative apartment buildings. (Courtesy of Donna Bazal Stone.)

Vivian and Bob Unger enjoy a mother-and-son moment while sitting on the Inwood marble outcrop near Isham Street across from Good Shepherd School in 1958. From the 1700s onward, there were several quarries in the area. A neighborhood to the north, across the Spuyten Duyvil, is today called Marble Hill. (Courtesy of Bob Unger.)

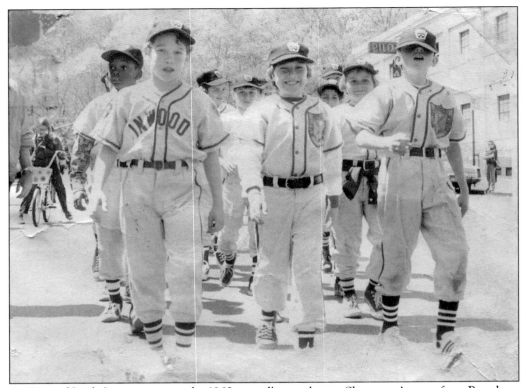

An Inwood Little League team in the 1960s proudly marches up Sherman Avenue from Broadway during the annual Opening Day parade. The league's first game was played on June 12, 1950. Later that month, two teams played an exhibition game at Yankee Stadium. NBA legend Kareem Abdul-Jabbar played in the league during the late 1950s and was once awarded his team's sportsmanship award. (Courtesy of Inwood Little League.)

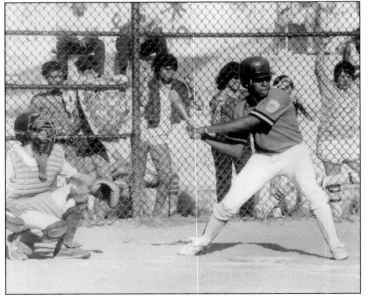

In this Inwood Little League photograph, probably taken in the late 1970s, Junior Serrano takes a cut at a pitch on one of the ball fields in Inwood Hill Park. In 1971, the league built Field 6, a Little League–scale diamond near the nature center of the park. (Courtesy of Inwood Little League.)

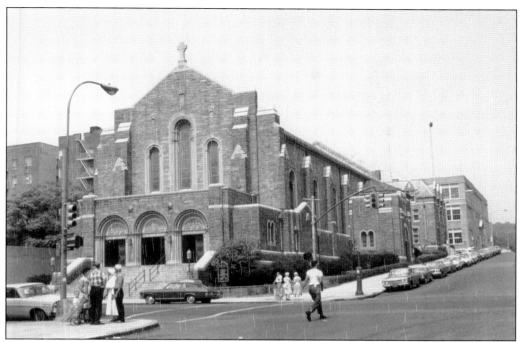

When this photograph of the Church of the Good Shepherd was taken in 1968, Inwood was experiencing a demographic shift. As second- and third-generation Irish immigrants moved out to the suburbs, an incoming, largely Hispanic population quickly filled the void, breathing new life into the neighborhood. Good Shepherd celebrated its first mass in Spanish in 1969. According to the 2010 census, 73 percent of Inwood identified as Hispanic. (Courtesy of Herb Maruska.)

Steel girders salvaged from the wreckage of the World Trade Center form a cross memorializing Inwood residents, including municipal and emergency personnel, who perished in the twin towers on September 11, 2001. 28 stones, one for each local victim, mark the site. A time capsule beneath the cross contains personal mementos of the fallen heroes. Several streets have been renamed to honor them.

A giant snowman stands sentinel as the sun sets over Inwood Hill after a pounding 2011 blizzard. The powerful nor'easter dumped 19 inches of snow on New York City. Schools were closed, and neighborhood kids enjoyed an Inwood snow day. (Courtesy of Rich Herrera.)

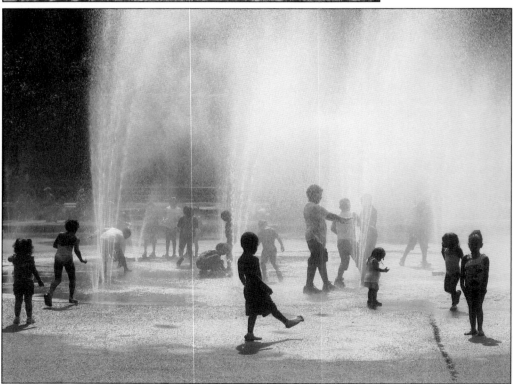

Silhouetted figures of children seek relief from the blazing summer heat in Fort Tryon Park's Anne Loftus Playground. Inwood's other public playgrounds are Indian Road, Emerson, Payson, and Monsignor Kett (the site of the annual Dyckman Basketball Tournament). (Courtesy of Alan Winokur.)

The Junior High School 52 chess team demonstrates their skills in a set of exhibition matches during an outdoor fair on Academy Street in 2012. A few blocks uptown, at Public School 98 on West 212th Street, the chess team regularly competes in the Elementary National Chess Championships. Students call their team "the Knightmares." (Courtesy of Osaliki Sepúlveda.)

Local photographer Bruce Katz captured this photograph of a harbor seal on the dock of the Columbia University boathouse in 2015. Three years later, in 2018, the seal (or perhaps another) reappeared on the waterfront where it frolicked, napped, and entertained folks along the Spuyten Duyvil. Residents named their summer neighbor Sealy. (Courtesy of Bruce Katz.)

Artist Will "Teez" Alicea converses with a customer stopping by his T-shirt stand at the Inwood Farmer's Market in 2012. The popularity of Alicea's graffiti-inspired apparel, with its bold graphics and pro-neighborhood messages, along with his gentle spirit, made him a neighborhood icon. Taken too soon, he died of leukemia in January 2013 at age 40.

The first Indian Day celebration took place in 1926 under the tree at Shorakkopoch during the dedication of Inwood Hill Park. The gatherings continued annually until at least 1945. Since 2002, Drums Along the Hudson has continued the tradition every spring. Here, Luis Sanakori Ramos and friends dance at the powwow. From 1926 to 1938, Inwood Hill Park contained a museum and outdoor exhibit called the Indian Life Reservation.

NY1 reporter Roger Clark interviews local Rabbi Herschel Hartz and pharmacy owner Manny Ramirez inside Dichter's Pharmacy in 2017. Ramirez took over the nearly century-old business after working there as a teenager. Forced to rebuild after a devastating 2012 fire, Dichter's now boasts an old-fashioned soda fountain and lunch counter. The excellent egg creams have been featured in a variety of media.

José Germosen expertly rolls tobacco inside Q Cigar by Portes on Broadway near West 214th Street. The cigars are made on site, rolled with tobacco from the Dominican Republic. The shop's owners, Rosa and Rafael Portes, import the tobacco leaves directly from their family's 75-acre farm in the small town of Tamboril, northeast of Santiago.

Hamilton star/creator Lin-Manuel Miranda has said this former bodega at Seaman Avenue and Dyckman inspired his 2008 Broadway hit *In the Heights*. "It was the first bodega where I spent the most time," Miranda told the *Daily News* in 2011. The bodega closed in 2014 to accommodate the expansion of Mama Sushi, a seafood restaurant. Dyckman Street is rapidly becoming a fine dining destination to a new generation of Inwoodites.

The Capitol Restaurant is an Inwood institution that dates back as early as the 1920s. For generations, the diner has been a popular late-night destination. "When the bars closed," a former Inwood police officer recalled of his 1960s midnight shifts, "I had to position myself in front of the Capitol Diner on Broadway and 207th Street, where all the drunks went, and sometimes tried to wreck the place."

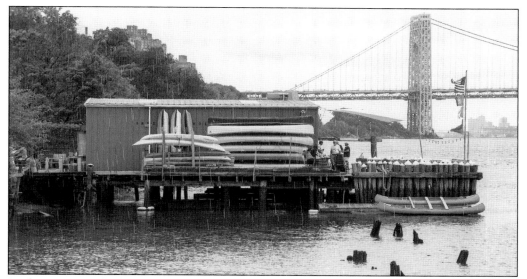

In the 1930s, as the lively waterfront culture in Inwood reached its zenith, the western end of Dyckman Street swarmed with boating activity. Since then, due to fires, changing recreational habits, and increased regulatory oversight, the number of Hudson River boathouses has been reduced to one: the Inwood Canoe Club. Once a club for highly competitive boatmen, it now hosts open houses for recreational paddlers.

Neighborhood son Bruce Reynolds sacrificed his life on September 11, 2001, so others might live. In 2016, the Port Authority police officer's heroism was recognized during a street renaming. Holding the new sign are Dominican-born congressman Adriano Espaillat (left) and city council member Ydanis Rodriguez (right). J.A. Reynolds, Bruce's father, is seated. Bruce's Garden, the half acre of public green space on Park Terrace East created in 1970, is named in Reynolds's honor.

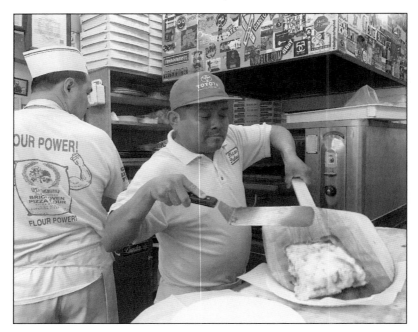

This pizzeria at 121 Dyckman Street has been slinging pies from the same location since around 1947. Greek immigrant John Kambouris took over the pizzeria in 1987 after owning a coffee shop on Sherman Avenue. Kambouris told the *Daily News* in 2012 that six-day workweeks at his famed Pizza Palace put his three kids through college. The Sicilian slice is to die for.

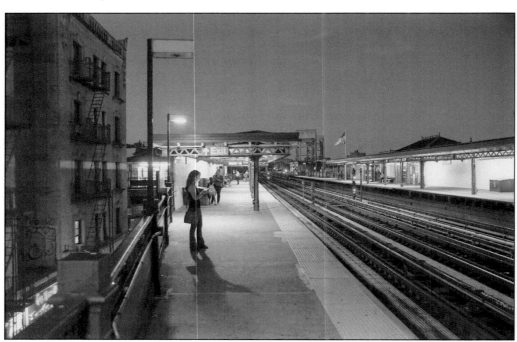

Inwood has come a long way from its days of being isolated from the rest of New York City. Today's commuters have their choice of subways, bus lines, nearby Metro-North trains, car services, and even a bicycle path down the west side to get where they need to go. Here, several people wait on the downtown platform of the 215th Street Interborough Rapid Transit (IRT) station on a quiet summer evening in 2017.

Artist Thor Wickstrom captures the light and shadows of the tree-lined Broadway sidewalk along Isham Park. Scenic views and a unique mix of city and country have attracted artists here for centuries. Ernest Lawson, Childe Hassam, and Norman Rockwell have all painted Inwood scenes. The Uptown Arts Stroll has featured local artists every June since 2002. The Northern Manhattan Arts Alliance and Inwood Art Works tirelessly promote the arts in northern Manhattan.

The sleepy railroad town once "ten miles from a beefsteak" has come a long way since beginning its voyage through time. No longer Manhattan's best-kept secret, Inwood now braces for what comes next. A rezoning plan approved in 2018 could change the look of the neighborhood by permitting construction of high-rise apartment buildings, bringing more residents to the tip of the island. How this next chapter plays out will be a tale told by future historians.

Discover Thousands of Local History Books Featuring Millions of Vintage Images

Arcadia Publishing, the leading local history publisher in the United States, is committed to making history accessible and meaningful through publishing books that celebrate and preserve the heritage of America's people and places.

Find more books like this at
www.arcadiapublishing.com

Search for your hometown history, your old stomping grounds, and even your favorite sports team.